IMAGES
of America

WARDMAN PARK HOTEL

The Wardman Tower

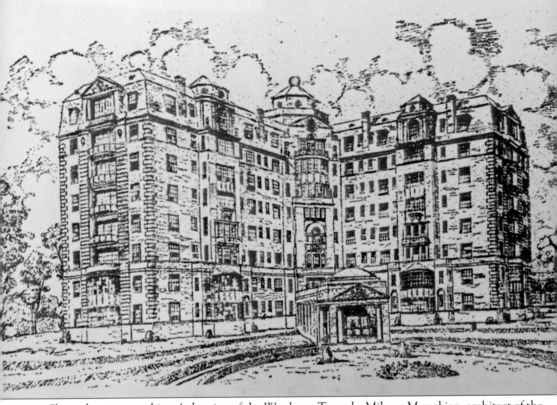

Shown here is an architect's drawing of the Wardman Tower by Mihran Mesrobian, architect of the apartment building. Mesrobian was also the chief architect for the restoration of the Dolmabahce Palace, which reopened as the sultan's residence in Turkey, and after immigrating to the United States, he became Harry Wardman's chief architect and designer. (Wardman Park Hotel.)

ON THE COVER: A vintage photograph of the Wardman Park Hotel showcases the dramatic, long driveway. (Library of Congress.)

IMAGES
of America

WARDMAN PARK HOTEL

Gregory J. Alexander
and Paul K. Williams

ARCADIA
PUBLISHING

Published by Arcadia Publishing
Charleston, South Carolina

Printed in the United States of America

Library of Congress Control Number: 2017952573

For all general information, please contact Arcadia Publishing:
Telephone 843-853-2070
Fax 843-853-0044
E-mail sales@arcadiapublishing.com
For customer service and orders:
Toll-Free 1-888-313-2665

Visit us on the Internet at www.arcadiapublishing.com

CONTENTS

ACKNOWLEDGMENTS

This book was commissioned by the Washington Marriott Wardman Park to commemorate the hotel's 100th birthday, to be celebrated in 2018. The book would not have been possible without the amazing support and cooperation the authors received from Cynthia McMullen, director of sales and marketing at Washington Marriott Wardman Park. Cynthia was gracious enough to host us at the hotel, which not only served as an information gathering session but also provided us with the ability to explore the grounds and be visually inspired to write this book. Also crucial to the book's success was the insight and historical knowledge shared by Oliver Walton, destination sales executive at the hotel. Cynthia and Oliver, we cannot thank you enough. Also, special thanks go to Jerry McCoy, special collections librarian at the Washingtoniana Division of the Martin Luther King Jr. Library, who helped us find valuable resources and images. Additional assistance was provided by feline editorial assistants Gypsy and Nomad.

Many thanks go to the Wardman Park Hotel for assistance in obtaining photographs. Other images were obtained from the Library of Congress (LOC), the Washingtoniana Division of the Martin Luther King Jr. Library (MLK), the James M. Goode Collection at LOC, National Photo Company, Getty Images, Wikimedia Commons, US National Archives and Records Administration, and the family of William and Margaret Byrd.

We hope this book allows readers to learn more about the rich history of the Wardman Park Hotel and that it pays proper homage to the incredible vision of developer Harry Wardman, who, despite many naysayers and obstacles, knew that a landmark hotel belonged in Woodley Park along Connecticut Avenue, and he made his dream a reality.

INTRODUCTION

For over 100 years, the Wardman Park Hotel has been viewed as one of Washington, DC's most desirable places to stay and, for the fortunate, even reside. What started as a potentially risky endeavor by developer Harry Wardman to build a luxury hotel in what was, at the time, seen as a rural setting has resulted in over a century of providing hotel guests and residents the finest accommodations and top-notch service, which has made the Wardman Park Hotel a landmark in our nation's capital.

After acquiring 20 acres in the Woodley Park neighborhood along Connecticut Avenue, Harry Wardman built a large, upscale home for his family. Less than a decade later, however, he had ambitiously decided to undertake the construction of a massive hotel on the property in 1918. Designed by architect Frank Russell White, the hotel would take full advantage of the pastoral setting. Rooms would be equipped with balconies, and many would feature ample windows to admire nearby beautiful Rock Creek Park. The access to natural light was a hallmark of White's design, allowing sunlight to envelop guests' rooms. Wardman had always wanted to create an atmosphere where guests would feel more like residents in a friend's home, so amenities such as billiards and card tables, high tea service, on-site grocery store and drugstore, and more were included in the design. Ten years after the construction of the hotel, Wardman razed his own home—without his wife's knowledge or permission—to make way for the Wardman Tower apartment building in 1928, designed by Mihran Mesrobian, who was known for his attention to detail. The apartments were large—some consisting of eight or more rooms—and residents were able to take advantage of all the amenities found in the hotel.

Those who lived at Wardman Park Hotel (the hotel had residents and hotel guests alike) and later the Wardman Tower apartment building were primarily an upscale demographic as the large apartments with luxurious appointments and top-notch amenities attracted Washington, DC, elites. It is no wonder that more presidents, vice presidents, and members of the Cabinet have resided at Wardman Park Hotel than at any other apartment building. Presidents Herbert Hoover, Lyndon B. Johnson, and Dwight D. Eisenhower, as well as Vice President Spiro Agnew and Supreme Court justice Earl Warren, all lived at Wardman Park Hotel. But it was not just politicians who were drawn to residential life at Wardman Park Hotel—socialite Perle Mesta and Hollywood screen legend Marlene Dietrich also once called Wardman Park Hotel home. All were attracted to the ability to live in a country club atmosphere in a quiet setting away from the hustle and bustle of downtown Washington, DC, yet close to such attractions as the National Zoo and Rock Creek Park.

In addition to the many political figures who have lived at Wardman Park Hotel, the hotel has long been the epicenter of political activity, especially when it comes to presidential inaugural balls. The hotel hosted every presidential inaugural ball from Herbert Hoover to George W. Bush, with one notable exception: Gerald Ford, who, upon becoming president after Nixon's resignation, chose not to celebrate the somber occasion. Early recordings of the venerable show *Meet the Press* were filmed there, and Wardman Park resident Lawrence E. Spivak was a panelist on the show. The hotel was also the scene of many important meetings, such as those involving the Manhattan Project, as well as critical military exercises through the years.

When the original hotel building was razed in 1979, one of the primary reasons behind the decision was to make way for a new hotel that would have more meeting and convention space to attract larger events and people who want to hold them in Washington, DC. Over the years, the hotel has built a series of ballrooms—each one bigger than the previous one—and they have been touted as some of the largest in the nation's capital. For convention goers, as well as hotel guests and apartment residents, the pools at Wardman Park Hotel have always been a draw. Several different pools have been constructed (and razed), but one aspect has always remained—the Wardman Park Hotel pool has traditionally been regarded as a place to be seen. Hotel guests have also enjoyed tennis courts, an ice-skating rink, and even a horse saddle club. In the 1950s, the hotel launched a miniature train, the Cherry Blossom Special, which transported guests all over the property.

Over the years, the hotel has seen new buildings constructed—the Motor Inn in 1964 and a more modern hotel in the late 1970s to replace Harry Wardman's original hotel structure. Today, the 1928 Wardman Tower building remains, although only the lower two floors are utilized for hotel guests, who enjoy opulent furnishings in grand suites. The upper floors have been converted into multimillion-dollar condominiums, and in 2014, the Woodley apartments opened adjacent to the hotel, with a design than mimics the architectural details seen in the original Wardman Tower. Marriott International has overseen management of the hotel since 1998, and in 2016, Marriott acquired Starwood Hotels & Resorts Worldwide, including the Sheraton brand, which operated the hotel for many decades beginning in the 1950s.

Although the hotel has seen several name changes, old buildings demolished, new ones erected, and changes of ownership since 1918, one constant has remained—an unrelenting dedication to providing hotel guests and residents with unparalleled service and an unforgettable experience while in residence at Wardman Park Hotel. It is no surprise that several hotel employees have worked here for decades and that the hotel has remained immensely popular for over 100 years.

One

EARLY DEVELOPMENT

Venerable Washington, DC, developer Harry Wardman had a vision—and persistence. Despite having few people championing his idea to construct a luxury hotel and apartment building in what was considered the "country" in the nation's capital, Wardman persisted and followed his dream.

Notwithstanding a written desire to retire in England, Harry Wardman built a three-story mansion in 1909 that featured a Spanish green tile roof and a stunning interior featuring mahogany woodwork. The home was located in a pastoral setting near the National Zoo; however, Wardman had bigger plans than simply relaxing in his home and enjoying the peaceful setting. Wardman initially envisioned constructing a series of apartment buildings on the 20 acres of undeveloped woodland he had purchased on Connecticut Avenue; however, he changed his mind and decided to instead build the Wardman Park Hotel in 1918.

Initially dubbed "Wardman's Folly" due to its remote location and that fact that it was not adjacent to the popular sites that drew tourists to the nation's capital, the hotel was an immediate success. Harry Wardman had proven everyone wrong. Architect Frank Russell White brilliantly designed the hotel so that 90 percent of the rooms would receive direct sunlight during the day, and the endless amenities—cocktail lounges, a drugstore, billiard tables, Turkish bath, grocery store, roof garden, tearoom, and more—created a unique feeling for guests who were treated more like residents.

The residential feeling was enhanced in 1928. While Lillian Wardman was away in Paris in 1928 supervising the education of their daughter Helen, Harry Wardman gathered his servants to work for 48 straight hours to remove all the furnishings from the family mansion so that it could be promptly razed and shortly thereafter replaced with the Wardman Tower apartment building, which remains today.

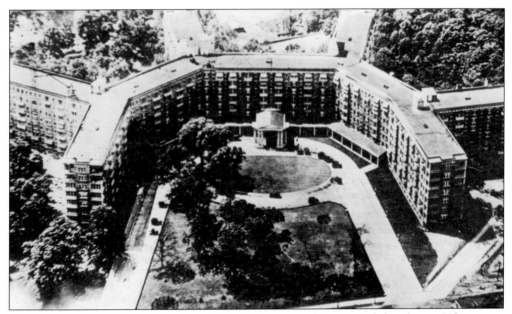

This 1920s postcard is an aerial shot from a US Army airplane of the Wardman Park Hotel, which was constructed in 1918. The hotel was one of five hotels in Washington, DC, created by the Wardman Construction Company. A July 7, 1925, article in the *Washington Star* notes that the new chain of five hotels would be considered one of the largest hotel organizations in the country and would include the Wardman Park, Carlton Hotel at Sixteenth and K Streets, the Annapolis at Twelfth and H Streets, the Portland Hotel, and the Gordon Hotel. (Authors' collections.)

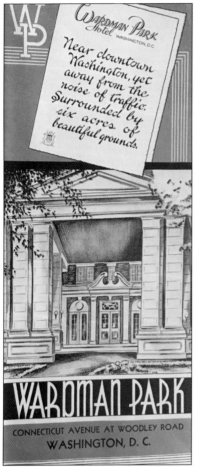

This early brochure touts the hotel's location "near downtown Washington, yet far away from the noise of traffic. Surrounded by six acres of beautiful grounds." Despite the initial fears that the location was too remote, the hotel was an instant success, filling to capacity shortly after opening. The residential portion of Wardman Park Hotel benefitted from a housing shortage in Washington, DC, making it very desirable. (Authors' collections.)

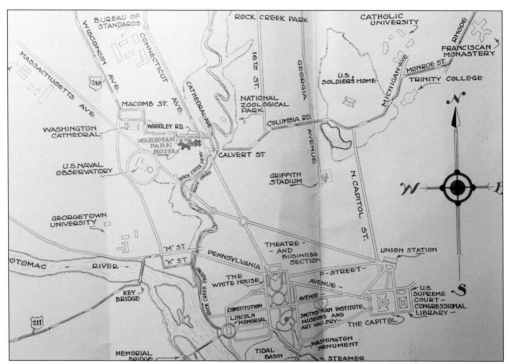

This early brochure illustrates the hotel's proximity to Rock Creek Park, the Naval Observatory, the Washington Cathedral, American University, the National Zoological Park, and Griffith Stadium, former home of the Washington Senators baseball team. (Authors' collections.)

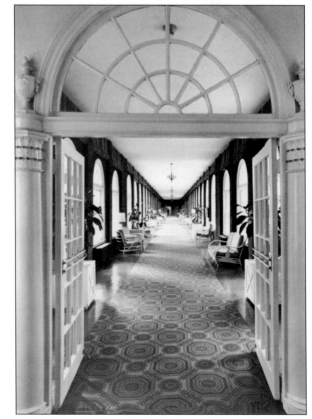

The large public corridor was designed in the Georgian Revival style with French windows and connected the Wardman Tower to the Wardman Park Hotel. (James M. Goode Collection, LOC.)

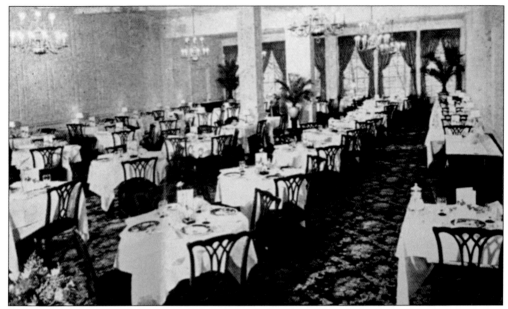

The Colonial Dining Room was reminiscent of the classical architecture of the Washington-Jefferson period. The focus on natural light was a hallmark of the hotel's design—the building was designed so that 90 percent of the rooms received direct sun at some time during the day. (Authors' collections.)

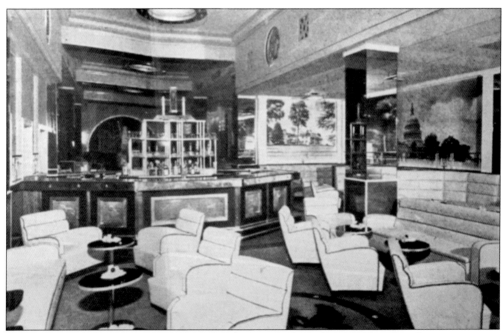

The Capital Cocktail Lounge was regarded as "one of Washington's outstanding attractions where food drinks and good fellowship prevail," according to a 1940s brochure for the hotel. Other amenities in the hotel included a drugstore, Turkish bath, billiard room, grocery store, roof garden, and tearoom. (Authors' collections.)

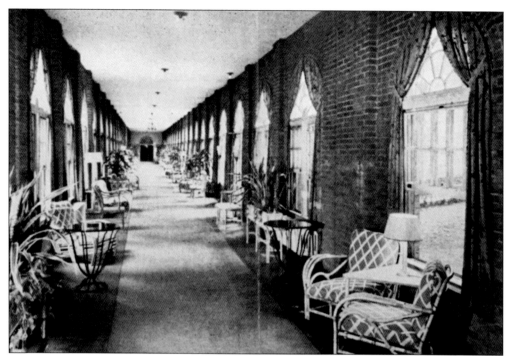

This is the picturesque promenade that connected the Wardman Park Hotel to the Wardman Tower, which was added in 1928. Its design was highlighted by large Georgian arched windows on each side to allow for ample natural light to illuminate the space. According to James M. Goode's in his book *Best Addresses*, architect Frank Russell White was inspired by the luxurious Homestead resort in Hot Springs, Virginia. Both hotels were large redbrick buildings with spoke-like wings set in landscaped parks. (Authors' collections.)

The 500-car garage, owned and operated by the hotel, was strategically placed behind the hotel. Guests approached the hotel via a dramatic, large, semicircular driveway, while the three-level garage was not visible to guests from the street. (Authors' collections.)

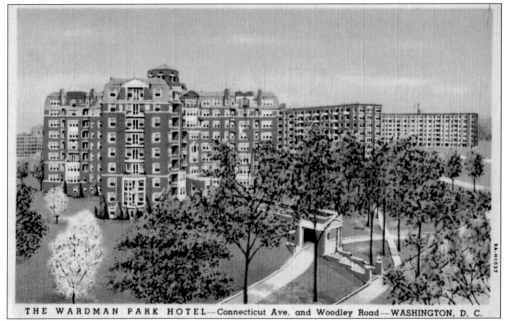

THE WARDMAN PARK HOTEL—Connecticut Ave. and Woodley Road—WASHINGTON, D. C.

Harry Wardman purchased 20 acres of undeveloped woodland on Connecticut Avenue for a complex of 10 apartment buildings, with more than 125 apartments, to be named Woodley Courts; however, in 1917, Wardman changed his mind and instead decided to build the Wardman Park Hotel in 1918. Seen below is a modern photograph showcasing how Harry Wardman's vision stood the test of time, as nearly 100 years later, the upper floors could easily be converted into high-end condominiums, a testament to Wardman's dedication to providing only the best residential experience. (Both, authors' collections.)

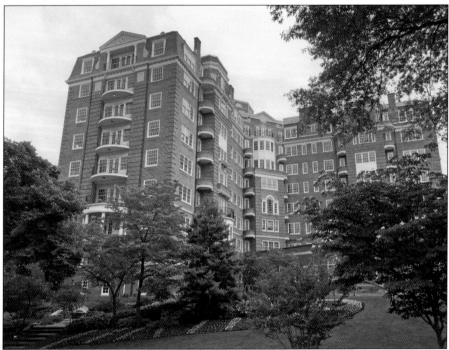

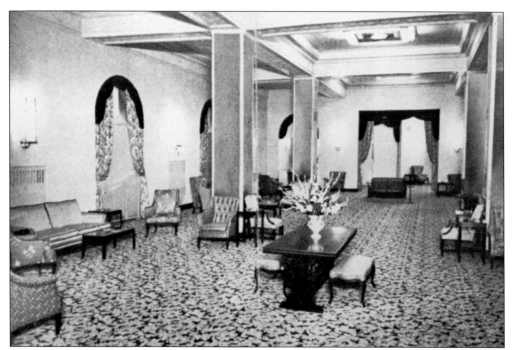

The impressive lobby at the Wardman Park Hotel is pictured above. Large columns and exposed beams in the ceiling, with exquisite Neoclassical plaster decor, created an ideal place for guests to relax. The lobby, a large irregularly shaped space that wrapped around half of the central service core, was approached through a screen of elaborate Corinthian columns. Three large arches filled with mirrors and plasterwork were found along the south side of the lobby, and an arcade of open and mirrored arches ran along the north side. Rich plasterwork also adorned the cornice around the lobby ceiling and the lowered ceiling beams. Draped classical figures, wreaths, and various floral motifs were common features in the plaster ornamentation. (Above, authors' collections; below, Wardman Park Hotel.)

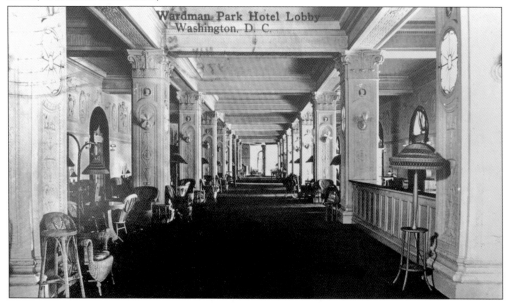

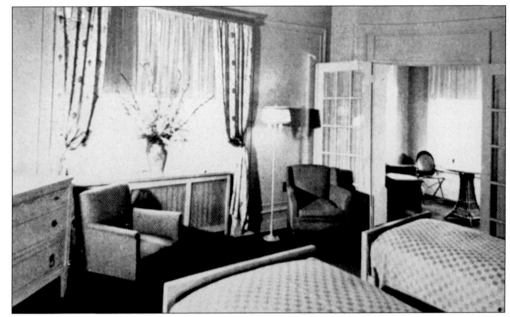

This was a typical guest room at the Wardman Park Hotel. Every guest room had an outdoor view. The hotel's architect, Frank Russell White, designed the U-shaped hotel so that it would face Woodley Road, while the wings of the hotel would radiate from the rear to face Rock Creek Park. Ninety percent of the rooms received direct sunlight at some point during the day. (Authors' collections.)

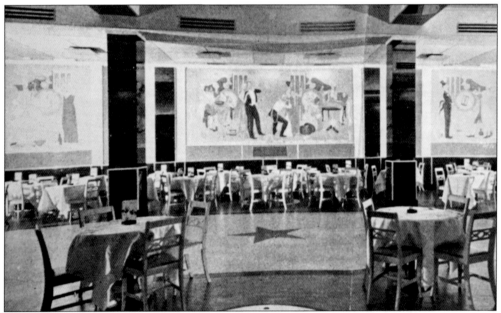

The nightclub at the Wardman Park was accented by a series of amusing murals. A January 15, 1937, article in the *Washington Post*, states: "The new supper-dance club at the Wardman Park Hotel strikes a new and fascinating note in decoration. Photograph-murals of Washington cover the walls of the cocktail room, and murals by Jack Lubin and Joseph Kossoff, the nightclub section." (Authors' collections.)

This rare 1930s–1940s luggage label is a symbol of a bygone era. In addition to helping identify one's luggage, these labels were often seen as a declaration of social status, as travelers were proud to boast their worldly adventures. (Authors' collections.)

This 1948 original advertisement urges guests to book a "Weekend at Wardman Park," as a vacation in the nation's capital. Superlative cuisine, delightful music, swimming pool, and tennis courts are all promoted, as are the hotel's natural surroundings. (Authors' collections.)

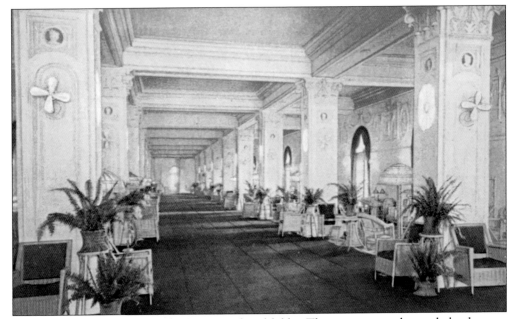

This vintage postcard shows the luxurious hotel lobby. The enormous columns helped create separate vignettes for sitting areas or to enjoy hot tea or cocktails. A 1928 advertisement promotes the hotel as having a "commanding view of the city from its tree-crowed height . . . the Wardman Park offers to its guests the unique combination of country club life and the most luxurious hotel service." (Authors' collections.)

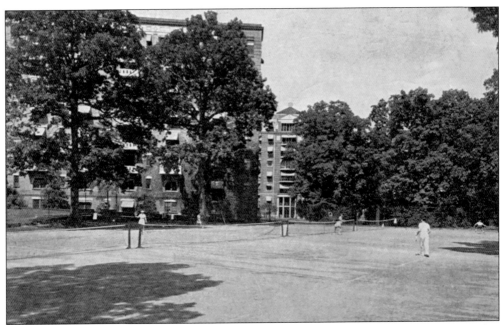

The hotel's championship Har-Tru tennis courts in a garden setting can be seen in this postcard. Still in business today, Har-Tru is known as the world's leader in tennis court surfaces. (Authors' collections.)

This original 1947 advertisement touts the hotel's many recreational opportunities and other amenities, including superlative cuisine, unobtrusive efficient service, tennis courts, swimming pool, and dancing. (Authors' collections.)

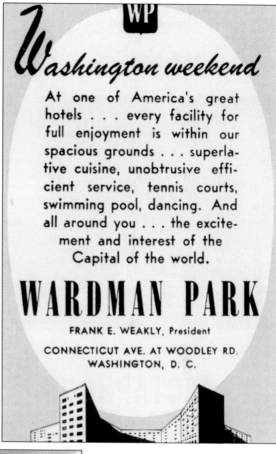

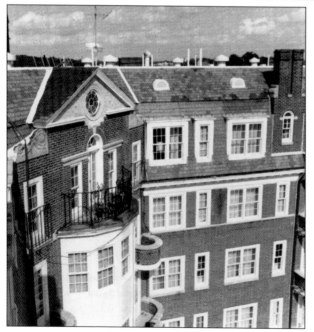

Wardman Park Tower featured a Georgian Revival facade. The attention to detail can be seen as far up as the top floors, despite these features not being readily visible to passersby, including a slate roof, round Georgian Revival windows, and intricate brick patterns on the chimneys. (James M. Goode Collection, LOC.)

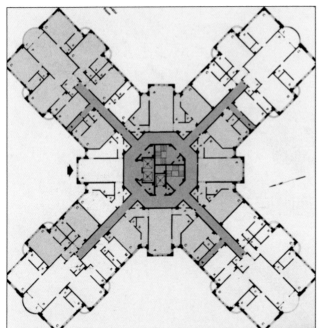

A floor plan for the Wardman Tower shows a number of large apartments. According to James Goode in *Best Addresses*, the $2 million Wardman Tower "was designed so that almost all rooms on each floor were connected . . . thus an apartment could be enlarged to any size." (James M. Goode Collection, LOC.)

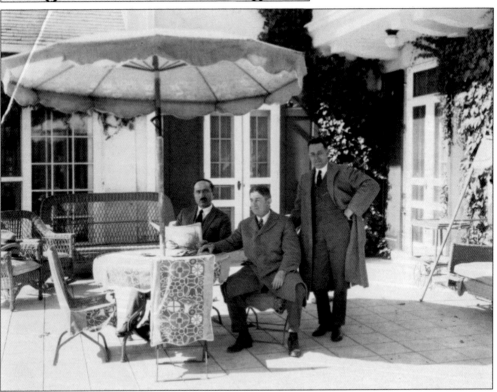

Mihran Mesrobian (left), a Turkish-born Armenian, was a well-known architect of apartment buildings. Mesrobian worked for Harry Wardman (center) and designed hundreds of houses, the Carlton and Hay-Adams Hotels, and the Wardman Tower. He designed for Wardman until Wardman's death in 1938. (National Photo Company.)

This vintage 1940s brochure lists shockingly low prices by today's standards. Single rooms and bath started at $4 daily, with double rooms and bath from $6 daily, and suites from $10 daily. The hotel marketed to business travelers and families, as well as the fastidious, by touting "an environment to suit the most discriminating taste." (Authors' collections.)

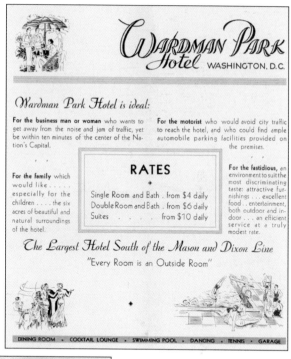

Architect Frank Russell White specialized in apartment building designs for Harry Wardman but also designed more than 5,000 single-dwelling houses for the Wardman Company. White is best known for designing the Wardman Park Hotel. However, White was arrested on October 26, 1931, in Baltimore on the charge of altering and raising $1 notes to represent $100 notes. He pleaded guilty in December of that year and served a two-year prison sentence. (James M. Goode Collection, LOC.)

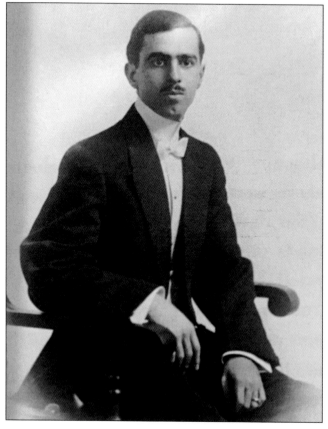

This architectural plan from the 1930s shows the design for the vestibule of the Pennsylvania Central Airlines Suite. Pennsylvania Central Airlines was a regional airline serving the Washington, DC, market. The suite included an Art Deco bar, large reception area, luxurious bedroom, and even a cardroom. It was designed by architect Donald H. Drayer and decorated by Genevieve Hendricks. (LOC.)

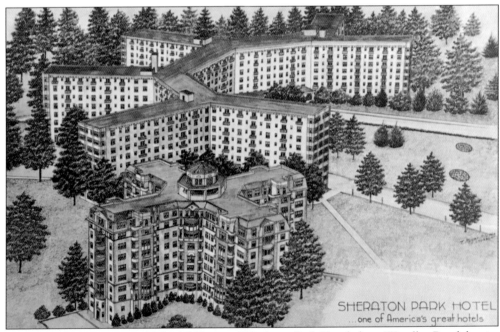

Harry Wardman constructed the 1,200-room Wardman Park Hotel along Woodley Road despite many local critics that said its location was not suitable for a hotel. Wardman proved them wrong, and his storied career included the construction of 9,000 homes, 400 apartment buildings, and several hospitals, schools, and clubs in Washington, DC. (MLK.)

Cherry blossoms have long been a draw for tourists to visit Washington, DC. Each year, the National Cherry Blossom Festival commemorates the 1912 gift of 3,000 cherry trees from Mayor Yukio Ozaki, of Tokyo, to the City of Washington, DC. The Wardman Park Hotel is a popular destination for those coming to see the colorful trees. Shown here are cherry blossoms in front of the hotel in the mid-1950s. (LOC.)

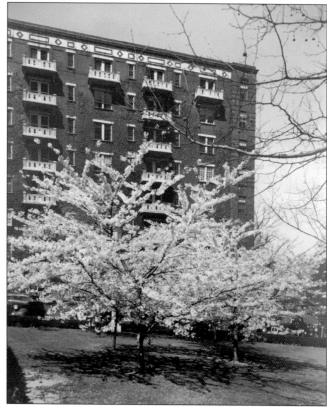

When he announced his plans to build the 1,200-room hotel, Washingtonians dubbed it "Wardman's Folly" because they thought no one would go to a hotel in what was then considered the countryside. Instead, the hotel brought the city to Woodley Park, providing prosperity and publicity for the quiet wooded area. (MLK.)

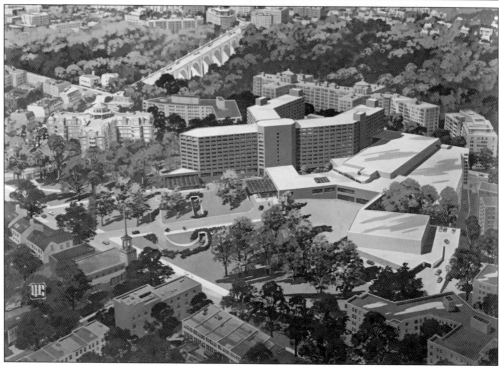

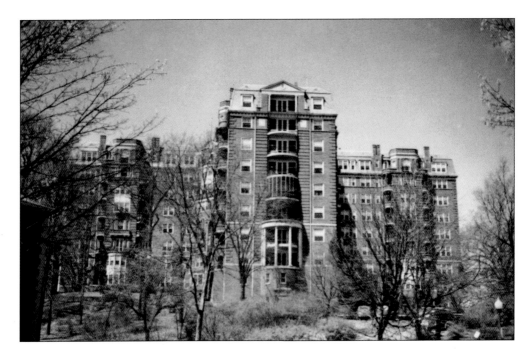

This April 3, 1948, photograph shows the south elevation of Wardman Tower. That same year, the hotel was granted by the Rent Control Administration the ability to raise rents by 13 percent for its 141 apartments occupied by permanent guests, including three senators and a dozen representatives. A February 21, 1948, *Washington Star* article explains that for the "unfurnished apartments the adjustments ranged from $90 to $100 a month for two rooms, kitchen and bath, to $408 to $465 for nine rooms, kitchen and four baths." Seen below is a modern photograph showing the same facade, reflecting the careful preservation of the architectural elements. (Above, LOC; below, authors' collections.)

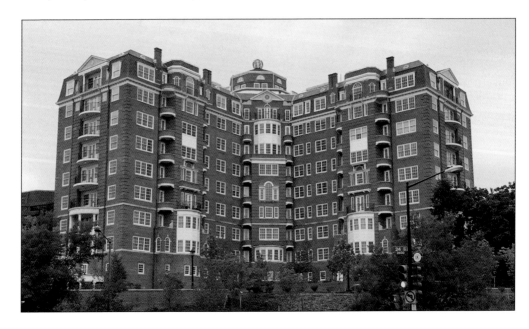

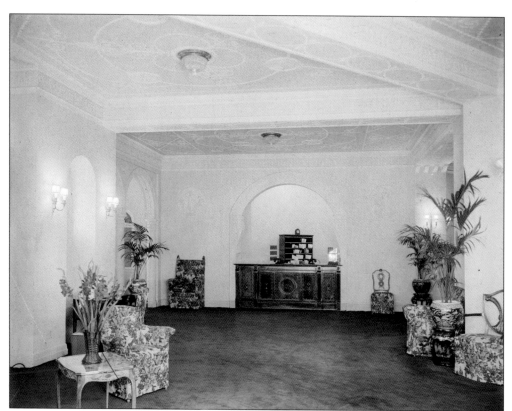

The elegant lobby welcomed hotel guests, as well as those in residence. In 1928, the lobby became a more bustling area with the opening of the new 300-room addition, Wardman Tower. According to a *Washington Post* article that year, Harry Wardman believed that "the wealthiest people are turning more and more to hotel life as a means of escape from the cares of large establishments." (LOC.)

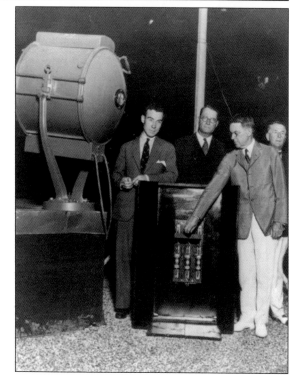

This July 24, 1929, photograph shows postmaster general Walter F. Brown lighting a huge revolving aircraft beacon atop the Wardman Park Hotel with, from left to right, Maj. Clarence M. Young; Gen. William E. Gillmore, USAAC; and Harry Wardman, hotel owner, looking on. The beacon was used by the *Washington Post* in 1932 to signal Franklin D. Roosevelt's presidential victory, but in 1942, it was taken down for the scrap pile for the war effort. (LOC.)

Guests of the hotel could peruse some of the offerings of the local high-end men's and women's furnishings store, Raleigh Haberdashers, while peaking into this elegant showcase. Commonly called Raleigh's, the DC–based store opened its first location in 1911 at 1109 Pennsylvania Avenue NW. Raleigh's had several locations until it closed its doors in 1992. (LOC.)

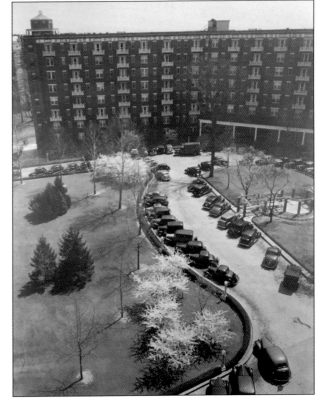

Since its opening, the facilities were used by 12 straight presidents for inaugural balls, from Herbert Hoover to George W. Bush—with one exception: Gerald Ford, upon becoming president after Nixon's resignation, chose not to celebrate the somber occasion. Nixon actually used the Wardman Tower during his first unsuccessful bid for presidency against John F. Kennedy, and in a peculiar coincidence, jurors for the Watergate trial were later housed in the tower. (LOC.)

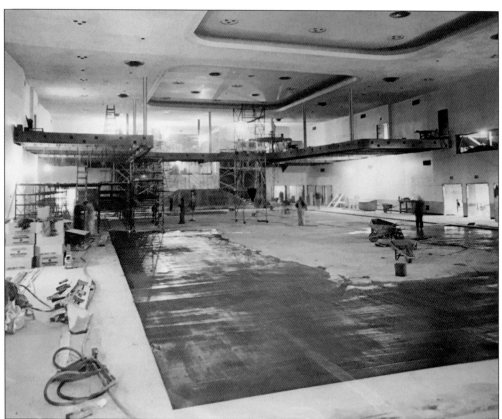

The ballroom of the newly constructed Sheraton-Park Hotel was photographed while it was under construction on May 3, 1955. The Sheraton Corporation had purchased the hotel and apartment property in 1953 and renamed it the Sheraton-Park Hotel. The hotel saw the need for bigger ballrooms to accommodate large groups, such as the Conference of Enrolled Actuaries, which has held its annual meeting at the hotel for 41 years and is booked for future years. (MLK.)

Richard F. Shore, the Sheraton-Park Hotel security man, is shown here making his rounds through the building. Wardman Park Hotel is known for its ability to retain employees for decades, as employees enjoy working in such a grand and historic hotel. (MLK.)

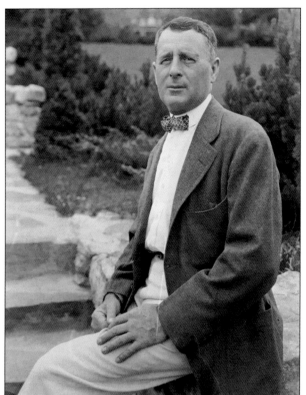

According to his own accounts, Harry Wardman left home in England and made his way to New York as a stowaway aboard the *Brittania* in 1889, although he had originally been bound for Australia. Soon after, he was offered a job at Wanamaker's Department Store in Philadelphia, before heading to Washington, DC, in 1885 with his first wife, Mary Hudson, who died just five years later. (LOC.)

Despite a written desire to retire in England, Wardman built an impressive home in 1909 at the site of the current Marriott Wardman Park Hotel. It featured an unusual Spanish green tile roof and was built three stories high with stucco and limestone and had an interior composed completely of mahogany. It featured a ballroom measuring 44 by 67 feet on the third floor and was built at a cost of $60,000. (LOC.)

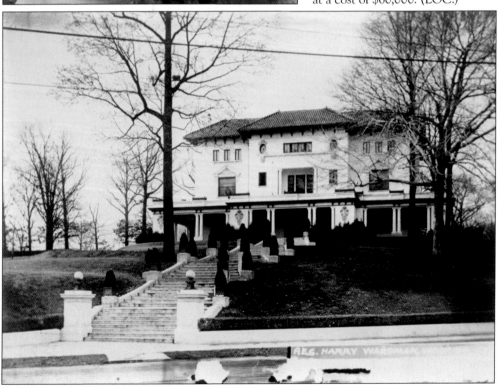

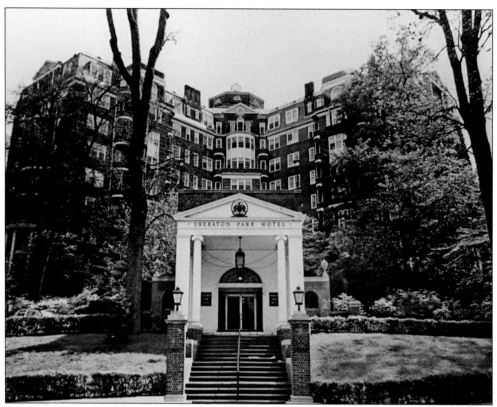

As Washington's preeminent convention hotel, the 1,338-room Washington Marriott Wardman Park Hotel is one of the largest hotels in the Washington, DC, metropolitan area. Throughout it history, it has been the home to numerous nationally known figures, including US presidents Hoover, Eisenhower, and Lyndon Johnson; vice presidents Charles Curtis, Henry Wallace, and Spiro Agnew; chief justices Frederick M. Vinson and Earl Warren; senators Charles Robb, Barry Goldwater, and Robert Dole; and even a Hollywood legend, Marlene Dietrich. (MLK.)

This photograph shows the mail center at the front desk of the hotel. In the 1940s, the world's first automatic telegraph machine for hotel guests was placed in operation at Wardman Park Hotel, publicly inaugurating the new communications service, Telefax. A *Washington Post* article notes that singer Kate Smith was on hand for the dedication and sent its first telegram. "The new system provides round-the-clock telegraph service for the hotel, with the desk clerk equipped with rate schedules to handle cash charges," the article says. (LOC.)

In 1908, Harry Wardman married his second wife, Lillian Glascock, of Asheville, North Carolina. They resided in a large home, complete with a stable, garage, and expansive grounds. Soon after the wedding, they soon departed for a three-month honeymoon in Europe, including a visit to Egypt. (LOC.)

While Lillian Wardman was away in Paris in 1928 supervising the education of their daughter Helen, Harry Wardman gathered his servants to work for 48 straight hours to remove all of their mansion furnishings so that it could be promptly razed and shortly thereafter replaced with the Wardman Tower apartment building. Financial difficulties, however, forced Harry Wardman to transfer management of the hotel, annex, and eight other large Washington properties to United Realties, Inc., and within a year, he was forced to sell all his property holdings. The properties were then refinanced through a group of investment bankers, and in 1931, the Wardman Park and Carlton Hotels were sold at auction. (LOC.)

Harry Wardman

REAL ESTATE
GENERAL INSURANCE
SALES, RENTS
HEADQUARTERS FOR APARTMENTS

1430 K STREET N. W.

PHONE MAIN 4190

Harry Wardman's first job in Washington was that of a carpenter, laying floors in an apartment building. Soon after his arrival in Washington, he started his own business with the construction of a few modest houses, beginning in 1897. Shown here is a 1920 advertisement in the *Washington City Directory* shortly after he built the Wardman Park Hotel. (Authors' collections.)

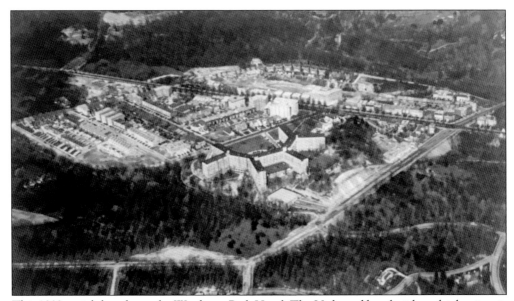

This 1922 aerial shot shows the Wardman Park Hotel. The U-shaped hotel with multiple wings is seen at center. Above the hotel is early residential development in the area, and the Connecticut Avenue Bridge can be seen to the right of the hotel. Six years after this photograph was taken, the Wardman Tower was completed. The undeveloped, wooded environment illustrates just how remote the hotel's location was at the time. (LOC.)

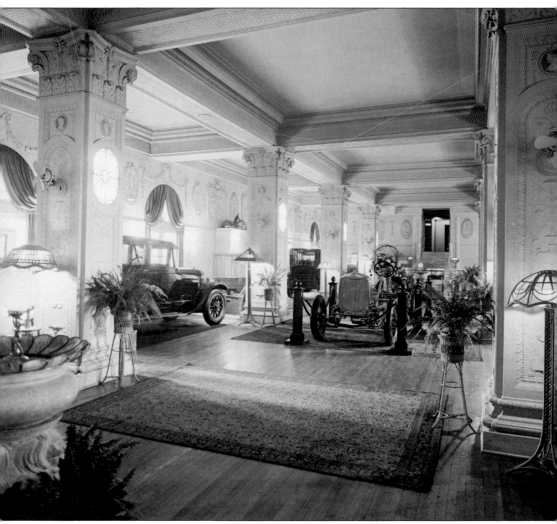

The enormity of the hotel's interiors allowed for such displays as this one by the Ford Motor Company. Ford purchased Lincoln in 1922 for $8 million, and the event at the Wardman Park Hotel was a great opportunity to showcase its new vehicles. Guests at the hotel during this time would have the opportunity for a rare glimpse into what was, at the time, a revolutionary invention soon to be owned by the masses. These two-door sedans are presumably from the 1922 production line, with the most unique identifying marks being the slope of the windshield and the shell surrounding the radiator grill. Note the white fans in the lobby installed before the advent of central air-conditioning. (LOC.)

This June 26, 1950, photograph shows the entrance of the Wardman Park Hotel. Three years later, controlling interest in the Wardman Park and Carlton Hotels was sold to the Sheraton Corporation for approximately $2 million. A newspaper article on May 25, 1953, notes that "Sheraton's national policy of non-segregation policy will be followed at the Wardman Park." (LOC.)

Intimate architectural details were not limited to the lavish rooms and lobby areas. Even the entranceways featured detailed designs to welcome guests, and the enormous grounds were seen more as a campus. (Authors' collections.)

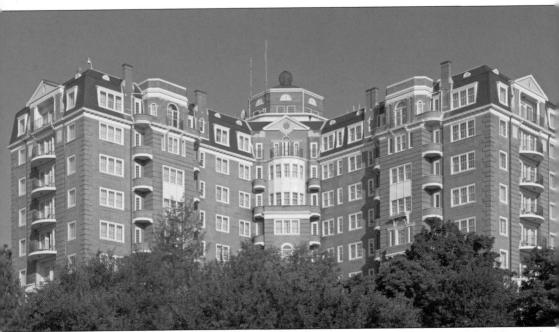

Atop the Wardman Tower section of the hotel is a unique skeletal iron globe. The globe, fabricated locally by Potomac Iron Works, capped the apartment wing of the hotel. It was a landmark for motorists driving on the Taft Bridge across Rock Creek Park. In 1986, in an attempt to capitalize on the excitement of the relighting of the Statue of Liberty, "The Sheraton General Manager arranged for the globe and an American flag to be spotlighted by red, white and blue lights, and to be turned on at the same time that President Reagan throws the switch to illuminate Miss Liberty," according to a July 3, 1986, article in the *Washington Post*. (Jürgen Matern/Wikimedia Commons.)

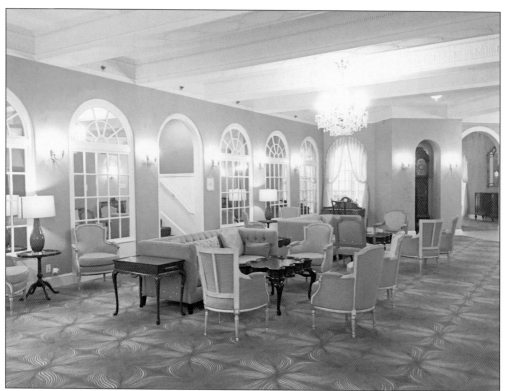

Unlike more traditional hotels of the era that had large, tall lobbies, the Wardman Tower had a more residential feel, allowing those both in residence and as hotel guests to feel as though they were invited to a friend's home for dinner. The space is still used today. In fact, on the February 1, 2017, anniversary of Langston Hughes's birthday, the Washington Marriott Wardman Park celebrated the great American poet with an evening of jazz and poetry and a performance of "The Weary Blues," his most influential poem. The evening also included the dedication of the new Langston Hughes Suite located in the historic Wardman Tower. (Authors' collections.)

The Wardman Tower lobby featured exquisite plaster motifs designed to delight hotel guests and were a testament to Harry Wardman's attention to detail. These motifs were so well executed that they have survived multiple expansions and renovations. (Authors' collections.)

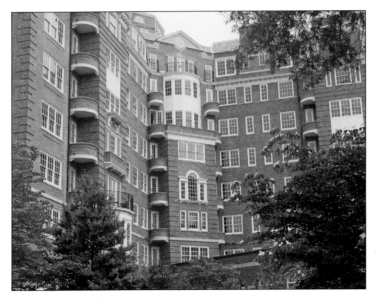

In the age before air-conditioning, architect Mihran Mesrobian cleverly designed small balconies that were less about allowing guests to sit outside and more about opening doors to create cross ventilation. This would allow cool breezes from nearby Rock Creek to provide relief for hotel guests and residents. (Authors' collections.)

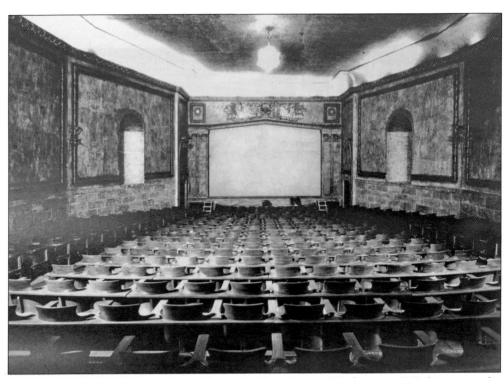

Although small, the Wardman Park Theater holds a place in Washington, DC, history, as the little theater movement started here as an experiment by the Moving Picture Guild of Washington in May 1926. In 1936, it held the local premier of *Things to Come*, according to Robert Headley's book *Motion Picture Exhibition in Washington, D.C.* It later was used for performing acts such as big band musician Herb Gordon and was converted into one of Washington's first television studios in 1946, where Jim Henson's Muppets made their debut. (Wardman Park Hotel.)

Two

RESIDENTIAL LIFE

One would be hard pressed to find an apartment building in Washington, DC, where more influential government officials have lived than Wardman Park Hotel and Wardman Tower. The original Wardman Park Hotel—designed by Frank Russell White for the Wardman Company—was constructed to be primarily a residential building, with apartments outnumbering hotel rooms. In 1928, the eight-story Wardman Tower was erected on the former site of developer Harry Wardman's mansion. The tower was aimed at well-heeled citizens with luxury apartments mostly ranging from five to seven rooms with the ability for expansion. Wardman Tower architect Mihran Mesrobian designed the apartments with luxurious appointments, including balconies to take advantage of the beautiful vistas.

The ability to reside in a luxury apartment with all the conveniences and top-notch service available from the Wardman Park Hotel was a natural draw for Washington elites. More presidents, vice presidents, and members of the Cabinet resided here than in any other apartment building. Presidents Herbert Hoover, Lyndon B. Johnson, and Dwight D. Eisenhower, as well as Vice President Spiro Agnew, all lived at Wardman Park. Earl Warren, President Eisenhower's appointment to the Supreme Court, also lived here. Warren is most notable for the case that made racial segregation in public schools unconstitutional and his heading of the investigation into Pres. John F. Kennedy's assassination. Longtime US senator Bob Dole and renowned socialite Perle Mesta also called Wardman Park home.

Wardman Park's emphasis on country club living with unparalleled service was also a hallmark of residing there. One of the hotel's most famous employees was poet Langston Hughes, who was a busboy at Wardman Park before his incredible talent was discovered and celebrated.

Outside the apartments, residents of Wardman Park relished the bucolic natural surroundings with 16 acres to explore on the expansive grounds. Also at residents' doorsteps were the National Zoo and Rock Creek Park. These two iconic places allowed residents to escape Washington, DC's notorious summer heat and humidity and cool off in one of the many streams found in Rock Creek Park, as well as explore the zoo's acres and acres of trails and animals.

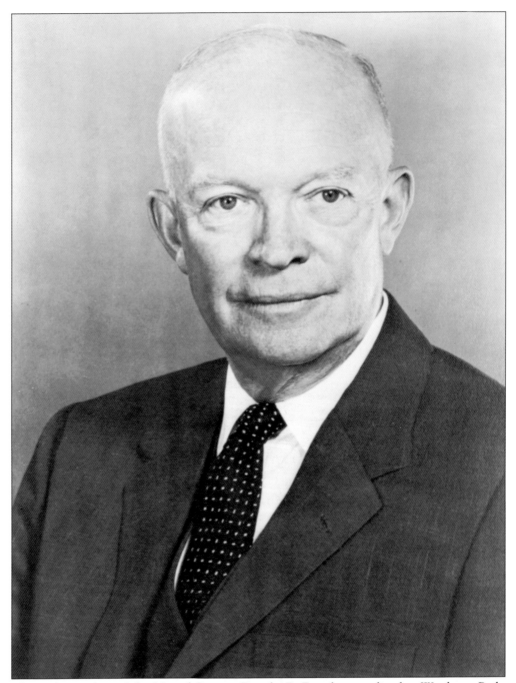

The 34th president of the United States—Dwight D. Eisenhower—lived at Wardman Park. According to the White House Historical Association, "Bringing to the Presidency his prestige as commanding general of the victorious forces in Europe during World War II, Dwight D. Eisenhower obtained a truce in Korea and worked incessantly during his two terms to ease the tensions of the Cold War. He pursued the moderate policies of 'Modern Republicanism,' pointing out as he left office, 'America is today the strongest, most influential, and most productive nation in the world.' " (LOC.)

One of Wardman Park's most notable residents was Earl Warren, who, in 1953, was appointed the 14th chief justice of the United States by Pres. Dwight D. Eisenhower. Among the Warren Court's most important decisions was the ruling that made racial segregation in public schools unconstitutional. Another was the "one-man one-vote" ruling that caused a major shift in legislative power from rural areas to cities. Besides his work on the court, Warren headed the commission that investigated the assassination of Pres. John F. Kennedy. (LOC.)

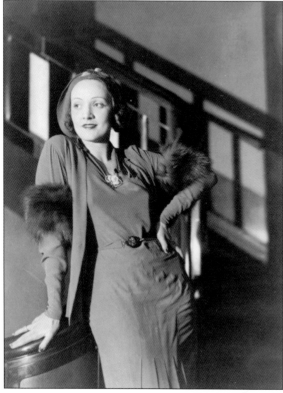

Politicians were not the only members of Washington's tony set to be drawn to Wardman Park. Hollywood legend Marlene Dietrich, a German actress and singer who later became a US citizen, lived in an apartment there. Dietrich's long career spanned from the 1910s to the 1980s and is most notable for films such as *The Blue Angel, Morocco,* and *Shanghai Express.* (LOC.)

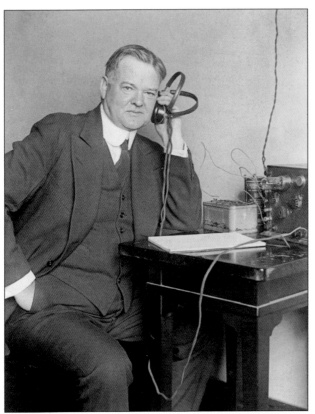

A Wardman Park resident, Herbert Hoover, shown here about 1925 listening to the radio, was elected president in 1928. Within a year of his election, the stock market crashed, causing the country to enter the Great Depression. Before his presidency, Hoover gained acclaim for his work as the head of the US Food Administration, where he was able to keep US troops fed during World War I while avoiding rationing at home. (LOC.)

Lyndon B. Johnson, who was sworn in as president on November 22, 1963, when Pres. John F. Kennedy was assassinated, also lived at Wardman Park. President Johnson is known for his Great Society legislation, which instituted civil rights, Medicare, Medicaid, urban and rural development, and aid to education and the arts, as well as his War on Poverty. (LOC.)

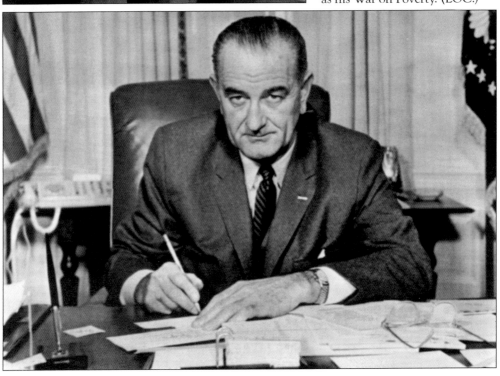

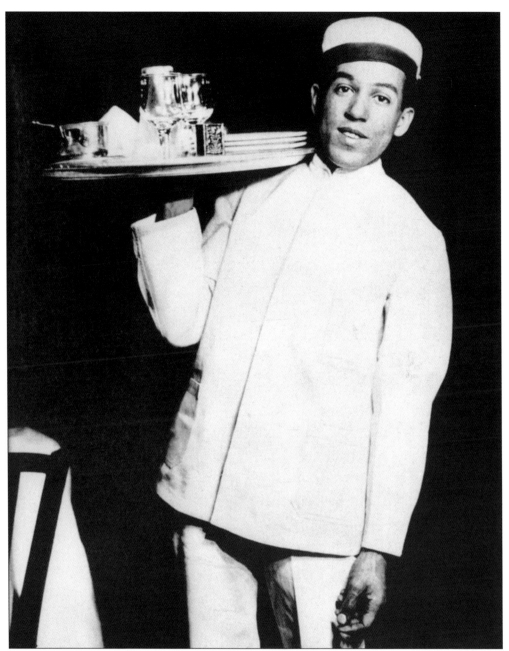

Future famed African American poet Langston Hughes moved to Washington, DC, in 1924 after a trip to Europe and Africa. After stints selling advertising at a local newspaper and working at a Laundromat and the Association for the Study of Negro Life and History, Hughes worked at the Wardman Park Hotel as a busboy. According to his obituary in the *New York Times*, "[Poet Vachel] Lindsay was dining at the Wardman Park Hotel in Washington when a busboy summoned his courage and slipped several sheets of paper beside the poet's plate. Lindsay was obviously annoyed, but he picked up the papers and read a poem titled 'The Weary Blues.' Lindsay called for the busboy and asked, 'Who wrote this?' 'I did,' Hughes replied." In 1930, Hughes's first novel, *Not Without Laughter*, won the Harmon gold medal for literature. (Getty Images.)

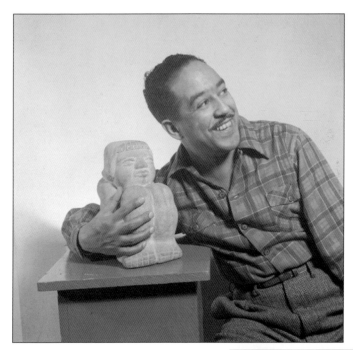

This 1943 portrait of Langston Hughes—who was discovered as a poet while working as a busboy at Wardman Park Hotel—shows the poet's comical side. Hughes is well regarded for his honest and insightful portrayals of black life in America. An accomplished poet, author, and playwright, Hughes is also seen as a pioneer for blending jazz and blues music into his poetry as part of the Harlem Renaissance of the 1920s. His writings are still seen as insight into the social consciousness of his time. (LOC.)

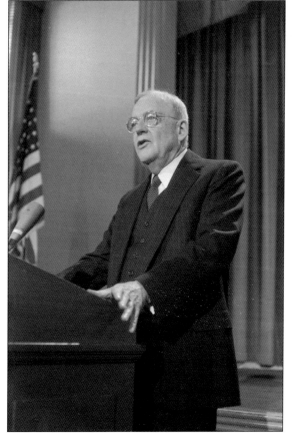

A native Washingtonian, John Foster Dulles was appointed secretary of state by Pres. Dwight Eisenhower on January 21, 1953. Dulles lived at Wardman Park. During his time as secretary of state, Dulles encountered numerous foreign crises, helped form a closer bond between the State Department and the CIA, and fought the rise of communism. Four days after his death in 1959, a bill was introduced to name the airport 26 miles west of Washington, DC, after Dulles. (LOC.)

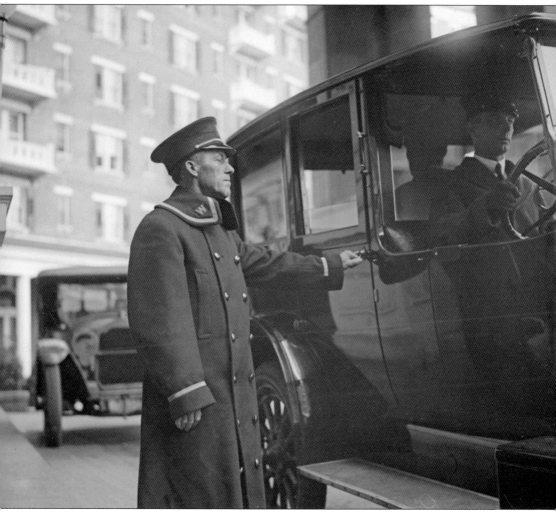

In 1921, a doorman assists arriving guests at the Wardman Park. One of the key duties of doormen is also to help guests and residents by hailing a taxi. However, according to a November 24, 1940, article in the *Washington Star*, residents of the hotel were having difficulty relying on taxi service to get to work, as taxis were not traversing Woodley Road enough, especially during rush hour. Recognizing the inconvenience, the management of the hotel hired a special bus to get residents to work on time. According to the *Washington Star*, the "bus moves down Connecticut Avenue and Seventeenth Street to Constitution Avenue and thence east to Capitol Hill." (LOC.)

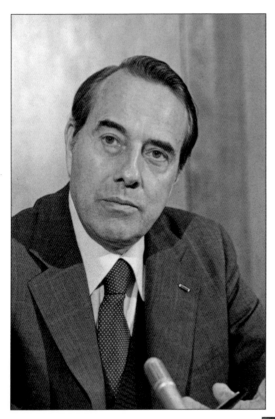

One of the most well-known residents of Wardman Park is Kansas senator Bob Dole, who served in Congress from 1969 to 1996. He served as the Senate majority leader, where he set a record as the longest-serving Republican leader. He was also the Republican nominee in the 1996 US presidential election, but he lost to Bill Clinton. (LOC.)

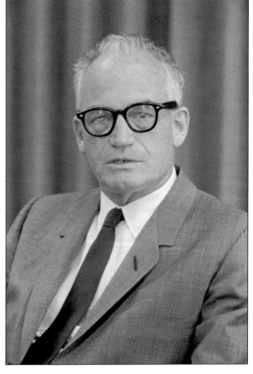

A conservative icon for his adherence to small government, Wardman Park resident Barry Goldwater represented the state of Arizona in the US Senate for 30 years. He ran for president in 1964 but lost in a landslide to Lyndon B. Johnson. After his loss, Goldwater returned to the US Senate until his retirement in 1987. (LOC.)

Wardman Park resident Fred M. Vinson, of Kentucky, holds the distinction as one of the few Americans to serve his country in all three branches of government. He was a member of the US House of Representatives for 12 years, was appointed a justice for the DC Court of Appeals by Pres. Franklin D. Roosevelt in 1938, and served as secretary of the treasury under Pres. Harry S. Truman. President Truman would later appoint him chief justice of the US Supreme Court, where Vinson served from 1946 until his death of a heart attack in 1953. He died in his apartment at the hotel. (LOC.)

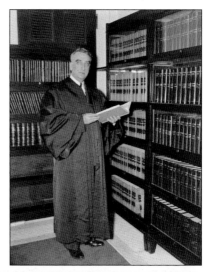

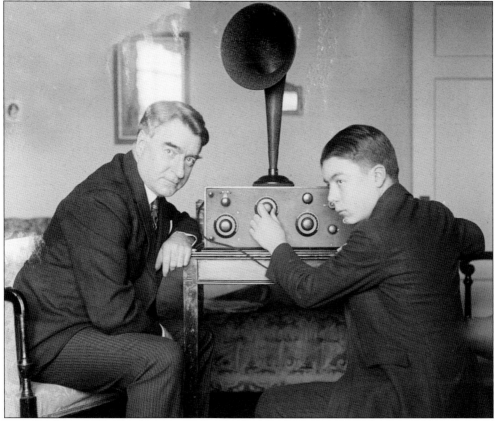

Sen. Royal S. Copeland and son Royal S. Copeland Jr. are listening to the radio in their apartment at the Wardman Park Hotel. While residence life at Wardman Park was quite glamorous, the hotel received a major upgrade in 1954 with the installation of air-conditioning in its rooms and public facilities in the main building. According to a July 4, 1954, *Washington Post* article, "Over five miles of copper and steel tubing will carry the chilled water to the rooms from five large cooling towers." (LOC.)

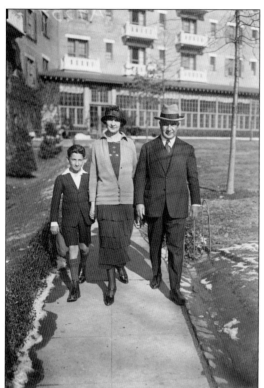

The new minister from Paraguay, Eusebio Ayala, who was the former president of Paraguay, arrived at the Wardman Park with his wife, Marcelle Durand, and their son, Roger. Many foreign dignitaries choose to stay at the iconic and elegant hotel. (LOC.)

This 1969 photograph shows the residential wing of the hotel. Sixteen years earlier, according to a May 25, 1953, article in the *Washington Post*, residents and hotel guests were alarmed when a drunken Marine, 2nd Lt. Francis O. Gallagher, "divested himself of his clothes [on the Wardman's front lawn]. The Marine decided to make a surprise entrance and still without clothes shinnied up a tree toward the second floor. He got off on the wrong floor, however, landing on a balcony where he broke a window and blundered into the apartment of Vice Admiral Emory S. Land, USN, ret." The Marine eventually made his way through the front lobby where he was met with large crowds and finally arrested. (MLK.)

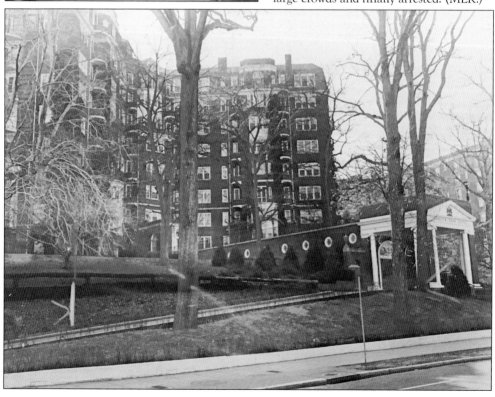

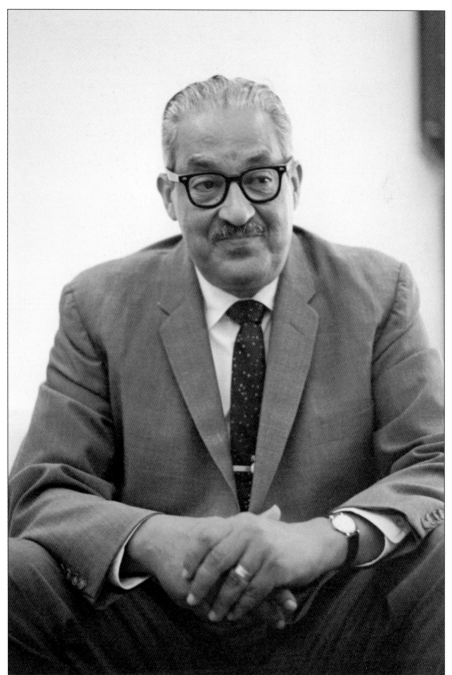

Thurgood Marshall, the first African American Supreme Court justice, is best known for winning the landmark legal case *Brown v. Board of Education*, which ended the legal segregation of black and white children in public schools. In 1954, Marshall was in need of a place to live while he prepared for and tried the case before the Supreme Court; however, Washington, DC, was a segregated city. The Sheraton-Park Hotel was the only hotel in the city that welcomed Marshall and his colleague, Charles Hamilton, to stay. In 2007, the hotel designated the Thurgood Marshall Boardroom, and the US Postal Service unveiled its Thurgood Marshall stamp at the hotel. (LOC.)

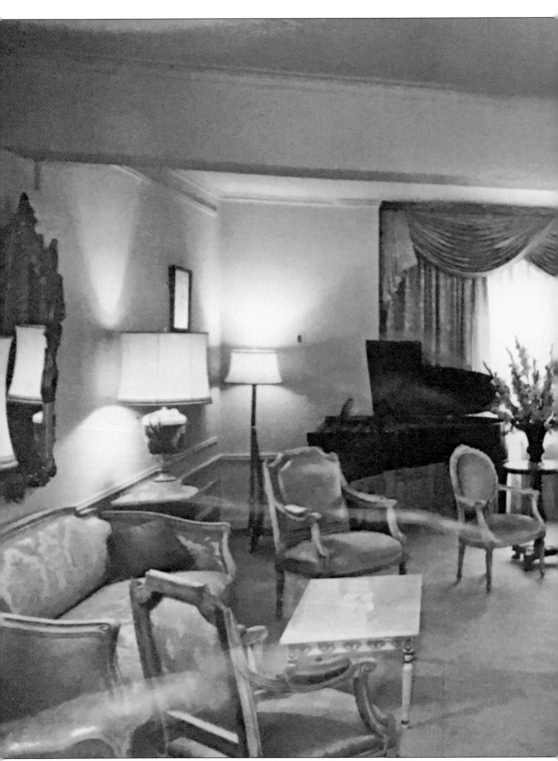

Shown here is Vice Pres. Spiro and Judy Agnew's future suite at the Sheraton-Park Hotel as it looked on February 7, 1969, when it was occupied by the Lyndon Johnson family, just after Agnew

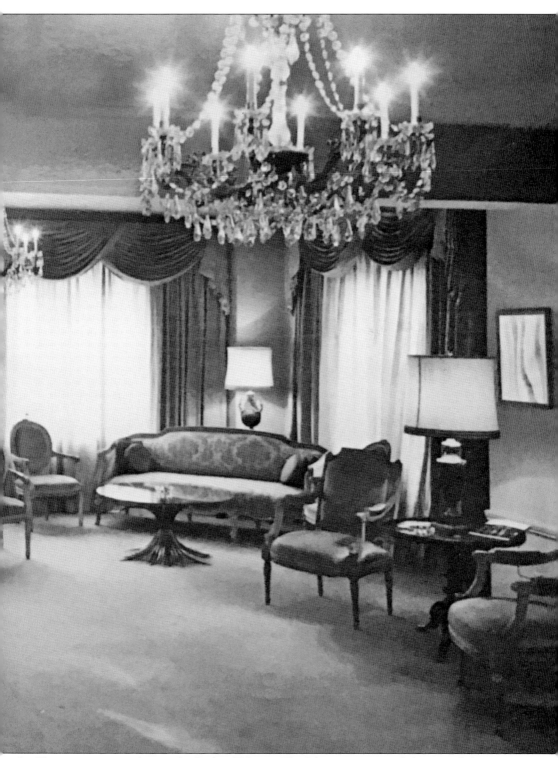

had become vice president under Richard Nixon. The Johnsons remained there until their new Spring Valley home was redecorated. (MLK.)

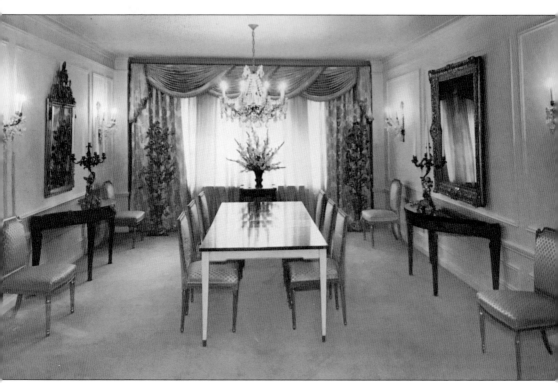

The Agnews' dining room, shown as it looked when President Johnson lived there in 1969, had a table that seated 10. There were four bedrooms, a library, and a kitchen with a pantry. Five years earlier, in June 1964, Washington police were called to the Sheraton-Park Hotel for a reported bomb threat less than 30 minutes before President Johnson made an unscheduled and unannounced visit to the hotel. (MLK.)

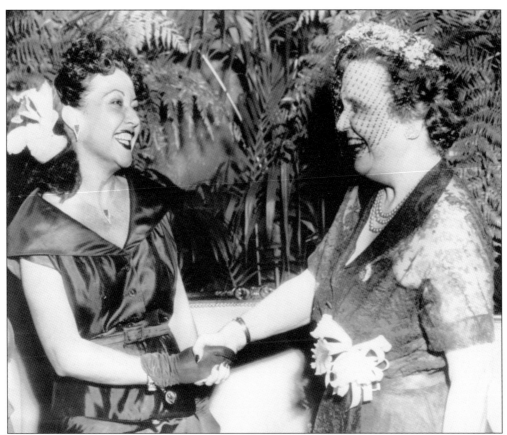

Perle Mesta (right)—a longtime social fixture in Washington, DC; resident of Wardman Park; and the US minister to Luxembourg—greets actress Ethel Merman of the play *Call Me Madam* at the American Newspaper Women's Club reception for Mesta. The play was believed to be patterned after Mesta's life as a woman diplomat. (Authors' collections.)

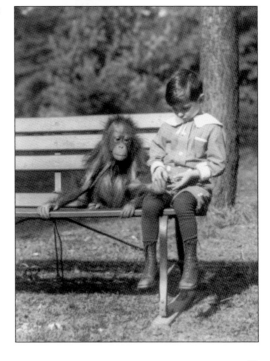

One of the many advantages of staying at the Wardman Park is the hotel's proximity to the National Zoo. Shown here is a young zoo visitor enjoying some fun time with an orangutan in the 1920s. The present monkey house, known as the New Mammal House, is one of only two original zoo buildings that remain today. (LOC.)

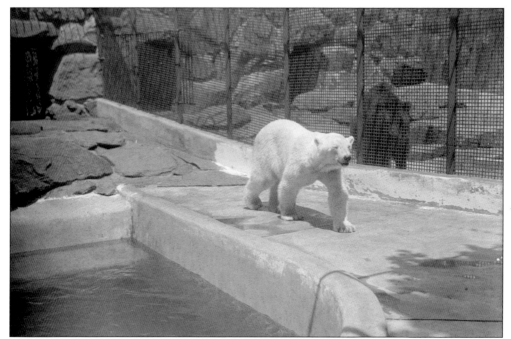

Some hotel guests have claimed that the National Zoo is so close that one can hear some of the animals as they roar. Shown here is the popular polar bear exhibit. Despite Washington's long, humid summers, polar bears seem unaffected by the heat at the National Zoo. (LOC.)

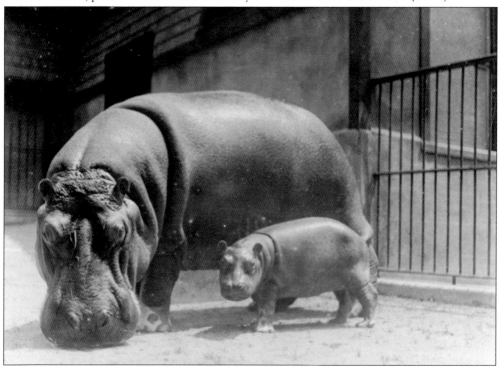

Literally steps away from the hotel is the National Zoo. Here, an adult and baby hippopotamus stroll around their habitat. (LOC.)

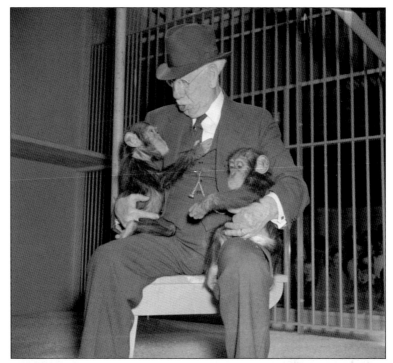

Head keeper William Blackburn makes friends with two young chimpanzees on March 25, 1938, shortly after their arrival. The chimps were six months old and were presented by George Siebold of Rockville, Maryland, a manager of a Firestone plantation in Liberia. (LOC.)

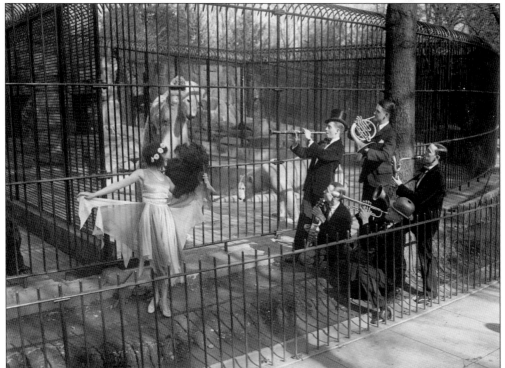

Five men of the Better Ole club orchestra play musical instruments in front of the polar bear exhibit at the National Zoo, while dancer Dolly Daye entertains Bruno the bear. While Bruno was entertained by the dancer, his female companion was said to be disinterested. (LOC.)

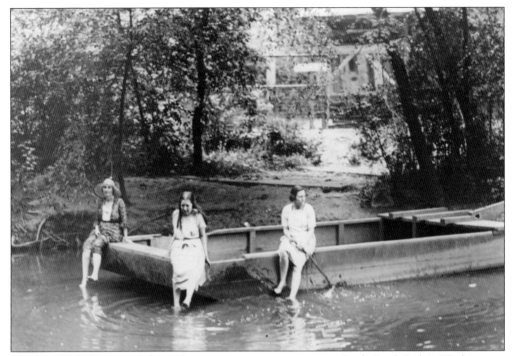

This late-1920s photograph shows three women sitting on a scow in Rock Creek Park in Washington, DC. The genesis of Rock Creek Park dates to 1866 when a Senate committee suggested finding a tract of land for the presidential mansion that had fresh air and clean water. (LOC.)

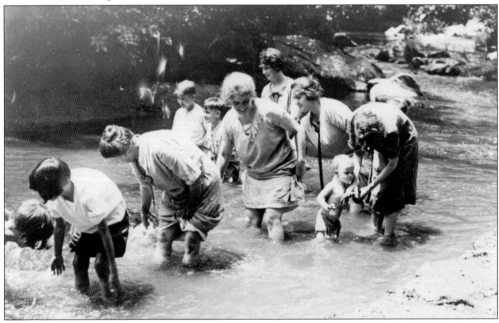

These 1920s women and children find some relief by wading in the creek on one of the hottest days in the history of the capital. Unlike other great American parks designed in the 19th century, such as Central Park in New York City, Golden Gate Park in San Francisco, and the Boston Metropolitan Park System, Rock Creek Park is a natural reserve. (LOC.)

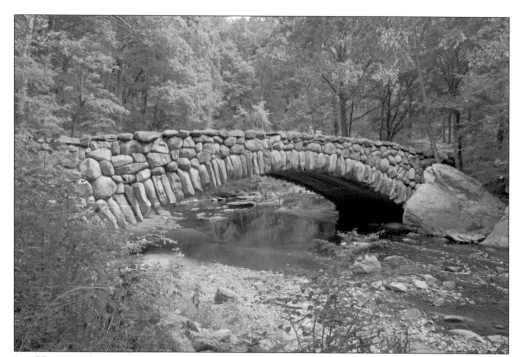

In addition to the bucolic grounds of the Wardman Park Hotel, guests also have unparalleled access to the countless trails and natural beauty of Rock Creek Park. Visitors can hike over 32 miles of trails in the park, enjoy a picnic, cycle, and explore local history via Civil War fortifications, working mills, and colonial houses. (LOC.)

Although he was ridiculed by other developers and architects for placing his hotel in what was regarded as a remote location of Washington, DC, at the time, Wardman's hotel got a boost with the construction of the nearby National Cathedral. As shown here in 1928, the same year Wardman Tower opened, large crowds gathered just to witness the construction of the cathedral. (LOC.)

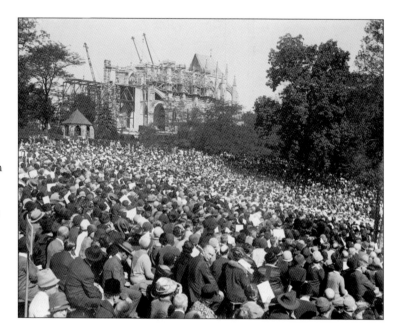

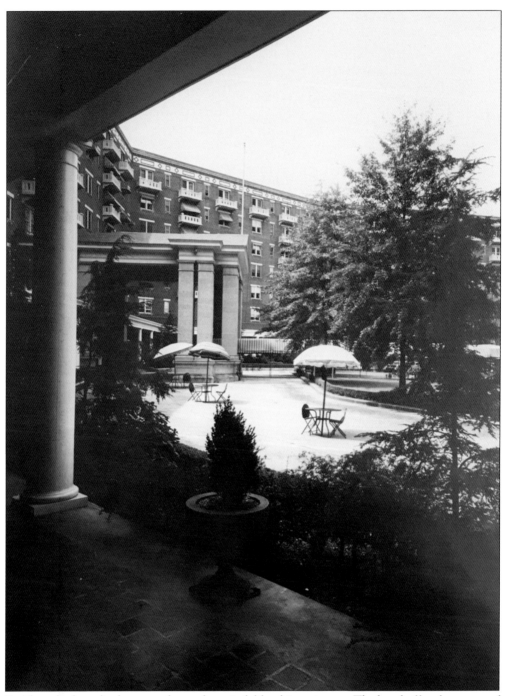

Residents had ample places to relax and unwind, like this patio area. The hotel offered an array of amenities for residents, including the addition of a small post office in the 1950s. According to a June 23, 1958, article in the *Washington Star*, "The clientele is cosmopolitan, but the atmosphere is as friendly as a small town in the little post office in the Sheraton-Park Hotel presided over by Mrs. Chauncey B. Stewart. VIP's and embassy personnel mingle with tourists and residents of the area at the Woodley Road Station." (LOC.)

Three

POLITICAL AFFAIRS

It is no surprise that an upscale hotel and apartment building located in the nation's capital would have a long and storied involvement with politics. In addition to the numerous presidents, vice presidents, and Cabinet officials who have resided at Wardman Park Hotel, the hotel has hosted every presidential inaugural ball from Herbert Hoover to George W. Bush, with one notable exception, Gerald Ford. Upon becoming president after Nixon's resignation, Ford chose not to celebrate. President Ford did, however, attend the Louisiana State Society's Washington Mardi Gras Ball at the hotel in 1975.

Among those presidents who held inaugural balls at the Wardman Park Hotel (later the Sheraton-Park Hotel) are Calvin Coolidge, Franklin D. Roosevelt, Dwight D. Eisenhower, Lyndon B. Johnson, Herbert Hoover, Harry Truman, John F. Kennedy, Richard Nixon, Jimmy Carter, Bill Clinton, and Ronald Reagan. Pres. Dwight D. Eisenhower, who once lived at the hotel, attended additional events there, as did Pres. John F. Kennedy. First Lady Eleanor Roosevelt hosted a grand birthday celebration for her husband, Pres. Franklin D. Roosevelt, to help raise funds toward the fight against infantile paralysis.

Due to its expansive exhibit and convention space, the Wardman Park Hotel was also used for many political conferences and events, including the World Bank and the International Monetary Fund. Some of the earlier meetings to discuss the Manhattan Project—which led to the creation of the world's first nuclear weapon—were also held at the hotel.

A few of the earliest episodes of *Meet the Press* were recorded at the Wardman Park Hotel, and Wardman Park resident Lawrence E. Spivak was a panelist for the show.

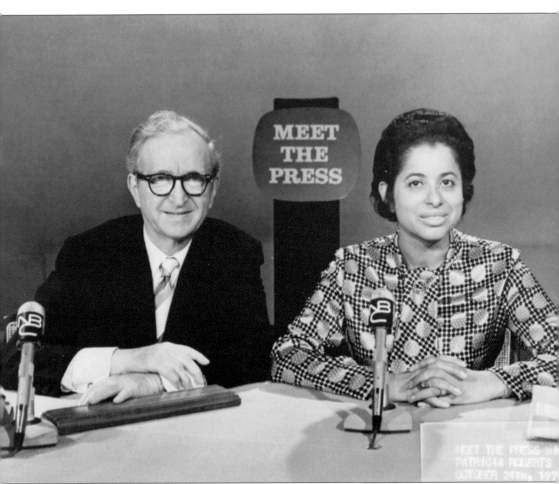

This photograph from *Meet the Press* shows Patricia Roberts Harris (right), the first African American woman to serve in a Cabinet post, under Pres. Jimmy Carter. She previously was the first African American woman to represent the United States as an ambassador, when she was the ambassador to Luxembourg under President Johnson. When she was questioned at her confirmation hearing to be secretary of Housing and Urban Development as to whether her background of wealth and power would make her ineffective, she replied: "I am a black woman, the daughter of a Pullman (railroad) car waiter. I am a black woman who even eight years ago could not buy a house in parts of the District of Columbia. I didn't start out as a member of a prestigious law firm, but as a woman who needed a scholarship to go to school. If you think I have forgotten that, you are wrong." (LOC.)

Some of the earliest episodes of NBC's hit show *Meet the Press* were filmed in the Wardman Park Hotel. Panelist Lawrence E. Spivak was a resident of the Wardman Tower. This April 10, 1955, photograph shows Spivak (left) and Louis Wolfson. (LOC.)

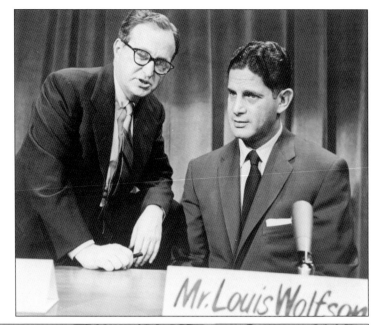

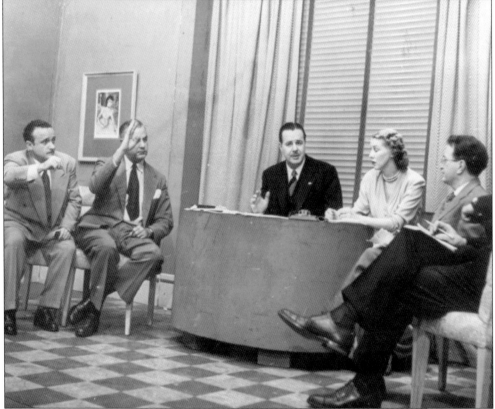

This photograph from October 31, 1948, shows a radio panel discussion from *Meet the Press* with Wardman Park resident Lawrence E. Spivak as a panelist (far right). On the air since 1947, *Meet the Press* is considered the longest-running show on television. (LOC.)

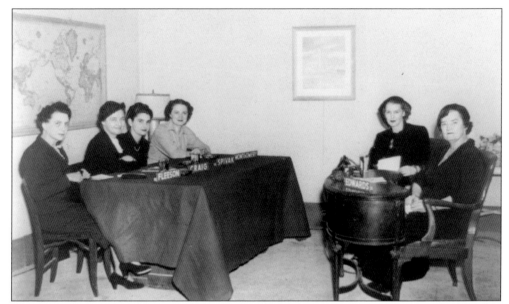

This December 10, 1949, photograph shows a panel of women, including India Edwards (far right). Edwards was a trailblazer in American politics as the executive director of the Women's Division of the Democratic National Committee (DNC). When the women's division was integrated into the DNC, she held the post of vice chairwoman. She encouraged President Truman to appoint several women to prominent positions, and at the 1952 Democratic National Convention, Edwards's name was included in nominations for vice president; she declined. (LOC.)

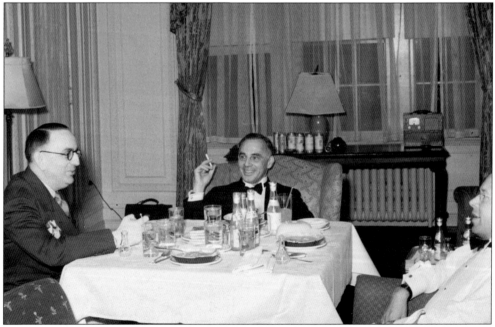

Warren Weaver, mathematician (left); Alfred Lee Loomis, philanthropist, attorney, banker, and physicist (center); and Ernest Orlando Lawrence (right) participate in preliminary meetings of the Manhattan Project in a room at the Wardman Park Hotel on April 22, 1940. (US National Archives & Records Administration.)

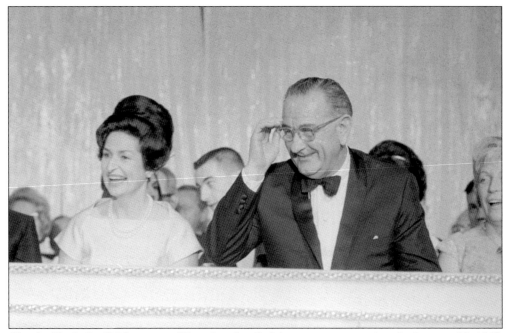

Claudia "Lady Bird" Johnson and Pres. Lyndon B. Johnson are pictured at the January 20, 1965, inaugural ball held at the Sheraton-Park Hotel. Stung by its landslide loss in the 1964 election, the National Federation of Republican Women met at the same hotel in 1967 with the slogan of "Women United for '68" and featured Phyllis Schlafly, a conservative author of A *Choice, Not An Echo*, which was the rallying cry of Barry Goldwater's 1964 presidential campaign. (LOC.)

Pres. Gerald R. Ford and First Lady Betty Ford greet costumed revelers at the Louisiana State Society's 28th Washington Mardi Gras Ball at the Sheraton-Park Hotel on February 1, 1975. (US National Archives & Records Administration.)

Besieged by autograph seekers, screen legend Janet Gaynor arrives at Pres. Franklin D. Roosevelt's birthday ball at the Wardman Park Hotel on January 29, 1938. (LOC.)

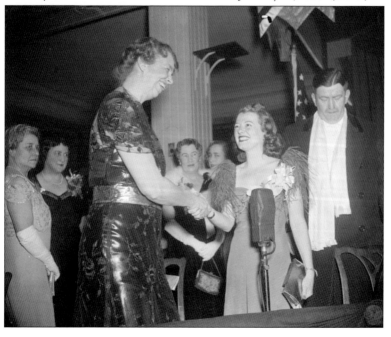

Making her rounds at the numerous birthday balls for President Roosevelt, Eleanor Roosevelt greets movie star Janet Gaynor, who came from Hollywood to entertain guests at the Wardman Park Hotel. (LOC.)

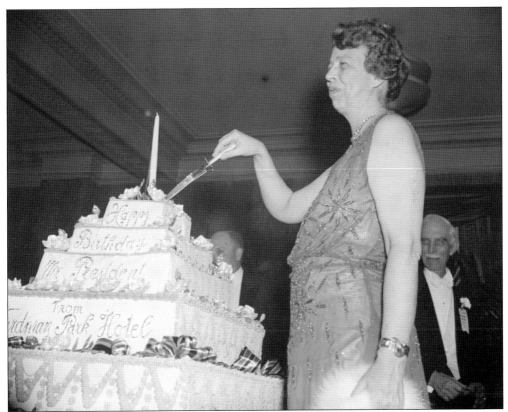

First Lady Eleanor Roosevelt cuts her husband's birthday cake. The stop at the Wardman Park Hotel was the last for Eleanor Roosevelt for the evening before returning to the White House to listen to the president thank the nation over the air for attending the numerous birthday balls, funds from which went toward the fight against infantile paralysis. (Both, LOC.)

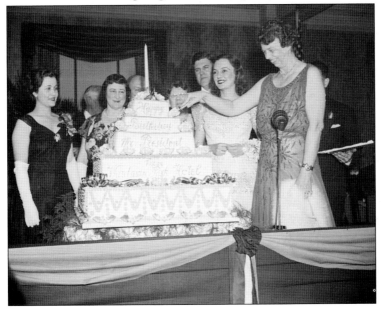

Eleanor Roosevelt arrives at the Wardman Park Hotel for a special event. In addition to being the longest-serving first lady in US history, after her husband's death, she pressed the United States to join and support the United Nations (UN) and served as the US delegate to the United Nations General Assembly from 1945 to 1952. She also served as first chair of the UN Commission on Human Rights. (LOC.)

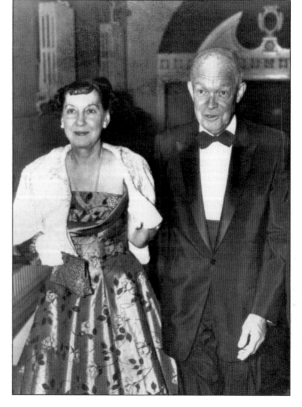

This May 20, 1957, photograph shows Pres. Dwight Eisenhower and his wife, Mamie, as they arrive at the Sheraton-Park Hotel, where they attended a dinner for the Cabinet given by Postmaster General Arthur Summerfield. As chairman of the Republican National Committee, Summerfield played a key role at the 1952 Republican National Convention by helping secure the nomination for Eisenhower by convincing the large delegation from Michigan, Summerfield's home state, to support Eisenhower's nomination. (Authors' collections.)

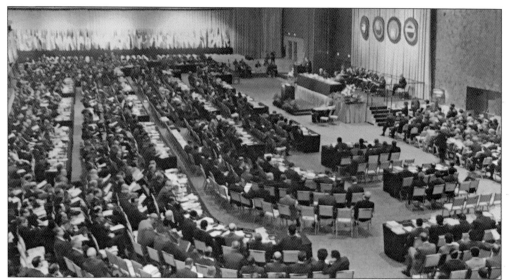

Shown here is a general view of Sheraton Hall at the Sheraton-Park Hotel during the September 26, 1966, annual meetings of the board of governors of the International Monetary Fund and the World Bank's opening session. (MLK.)

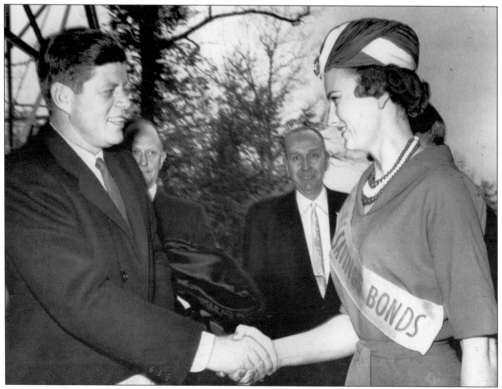

Pres. John F. Kennedy, pictured on January 19, 1962, is greeted by Emily Terrall of St. Helens, Oregon, who was Mrs. US Savings Bonds. President Kennedy was at the Sheraton-Park Hotel to attend a US Treasury bond conference. In the background are Treasury Secretary C. Douglas Dillon (left) and George D. Johnson (right), general manager of the Sheraton-Park Hotel. (Authors' collections.)

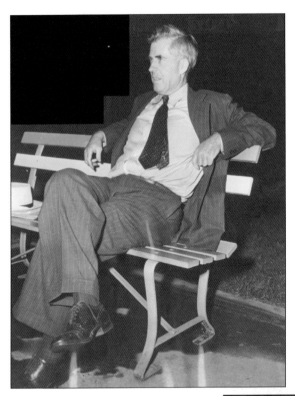

Vice Pres. Henry A. Wallace lounges on a park bench at the hotel in this July 14, 1944, photograph. Wallace was vice president under Franklin D. Roosevelt; however, he only served one term as public feuds with Democratic Party officials and his perceived soft stance on the Soviet Union led to his political demise—he was dropped from the ticket in 1944 in favor Harry Truman. (Authors' collections.)

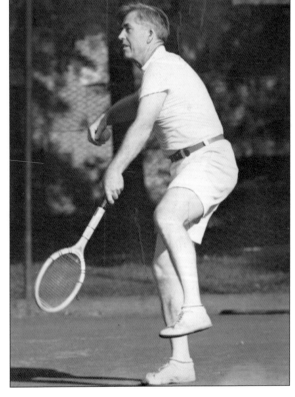

This 1942 photograph shows Vice Pres. Henry A. Wallace playing tennis on the courts of Wardman Park Hotel, where he resided while in Washington, DC. It was reported that Wallace played tennis almost every morning before starting the work duties of the day. (Authors' collections.)

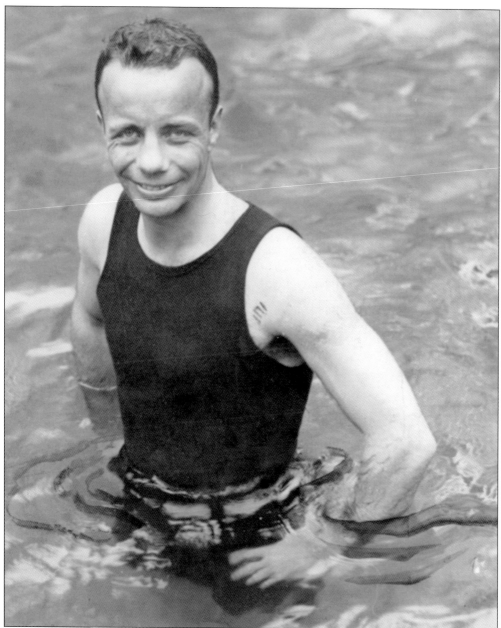

Theodore Roosevelt III, better known as Jr. and the eldest son of Pres. Theodore Roosevelt and Edith Roosevelt, kept cool with a daily plunge in the pool at Wardman Park, as seen in this September 10, 1922, photograph. At the time, he was assistant secretary of the Navy, the same post his father held many years prior. Roosevelt Jr. would later serve as governor of Puerto Rico. He served in both World War I and II, and he led the first wave of troops at Utah Beach during the Normandy landings in 1944. He died in France one month later. (Authors' collections.)

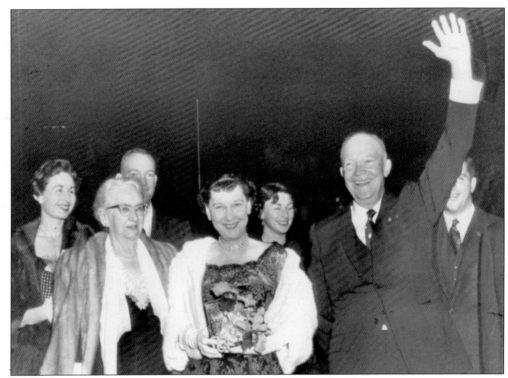

Above, on November 6, 1956, Pres. Dwight D. Eisenhower and members of his family arrive at the Sheraton-Park Hotel to attend a large GOP party and await the outcome of the election. The party must have been a joyous one, as Eisenhower easily won reelection that evening over Adlai Stevenson. Below, President Eisenhower celebrates his birthday with a grand cake and well-wishers at the Sheraton-Park Hotel. (Above, authors' collections; below, Wardman Park Hotel.)

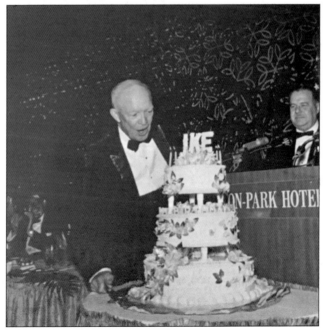

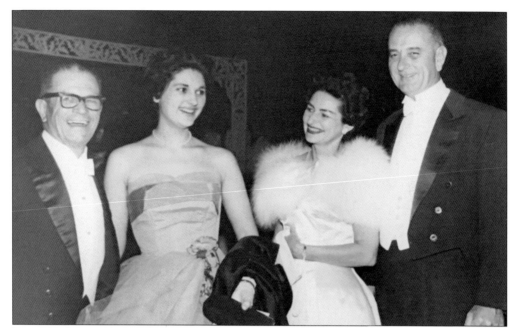

Pres. Lyndon B. Johnson (at right with his wife, "Lady Bird" Johnson, at his side) is pictured at his 1965 inaugural ball at the Sheraton-Park Hotel. Johnson became president in 1963 after the assassination of John F. Kennedy. He is best known for his domestic policies that tackled poverty, secured voting rights for African Americans, and banned discrimination in public facilities. (Wardman Park Hotel.)

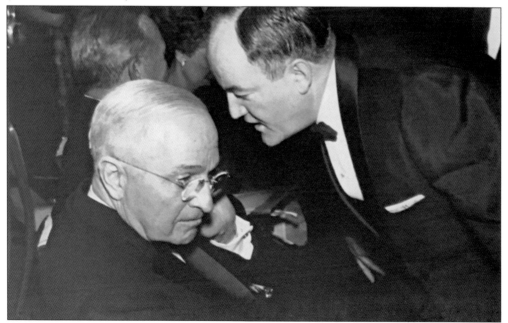

Pres. Harry S. Truman (left, with Sen. Hubert Humphrey) celebrates at his inauguration held at the Sheraton-Park Hotel. Truman became president after the death of Franklin D. Roosevelt. He is remembered for the Marshall Plan, which helped rebuild Western Europe's economy; establishing NATO; and for intervening in the Korean War. (Wardman Park Hotel.)

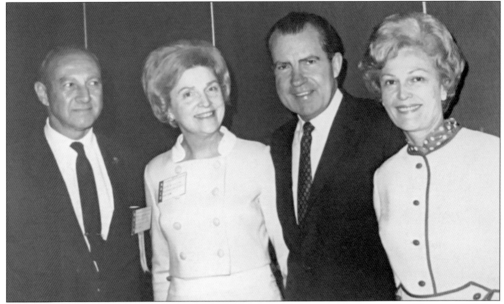

Pres. Richard Nixon (second from right with wife, Pat, at far right) is pictured here in 1968 at the Sheraton-Park Hotel. During his tenure in the White House, Nixon ended the Vietnam War, brokered diplomatic relations with the People's Republic of China, and established the Environmental Protection Agency. However, he is most remembered for the Watergate scandal that forced him to resign from the presidency. (Wardman Park Hotel.)

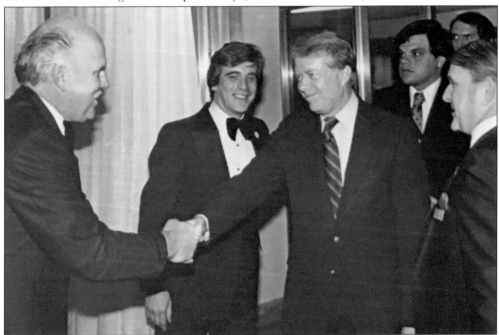

Pres. Jimmy Carter arrives at the Sheraton-Park Hotel. A relative political unknown nationally, Carter scored an unlikely win over incumbent president Gerald Ford in the 1977 presidential election. However, economic troubles and the Iran hostage crisis were his downfall when he ran for reelection in 1980. (Wardman Park Hotel.)

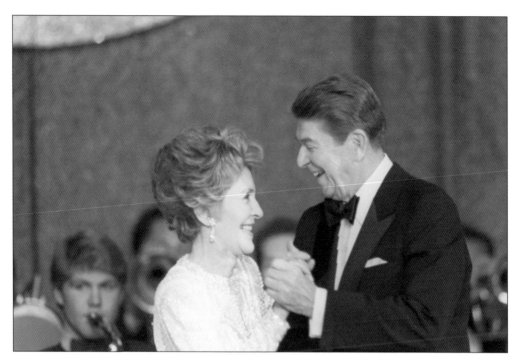

Pres. Ronald Reagan and Nancy Reagan dance together at the inaugural ball held at the Sheraton Washington Hotel on January 21, 1985. (US National Archives & Records Administration.)

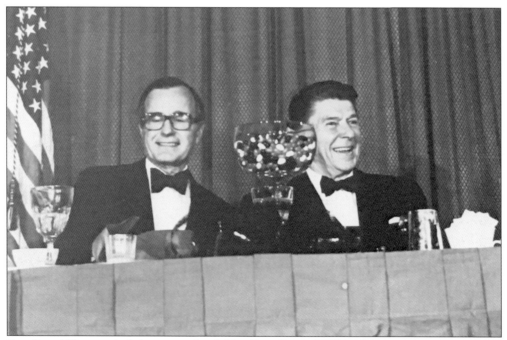

Pres. Ronald Reagan (right) is pictured with Vice Pres. George H.W. Bush at Reagan's 1981 inaugural ball at the Sheraton Washington Hotel. The previous year, Reagan had defeated incumbent president Jimmy Carter. Reagan won reelection in 1984 in one of the biggest landslides in US history. Vice President Bush succeeded him as president in 1988. (Wardman Park Hotel.)

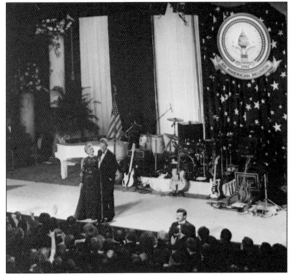

Pres. Bill Clinton is pictured with First Lady Hillary Clinton at his 1993 inaugural ball at the Sheraton Washington Hotel. During President Clinton's tenure, he presided over the longest period of peacetime economic expansion in American history. In 1998, President Clinton was impeached by the House of Representatives for his role in the Monica Lewinsky scandal. After his term ended in 2000, he created the William J. Clinton Foundation to address international causes, such as the prevention of AIDS. (Both, Wardman Park Hotel.)

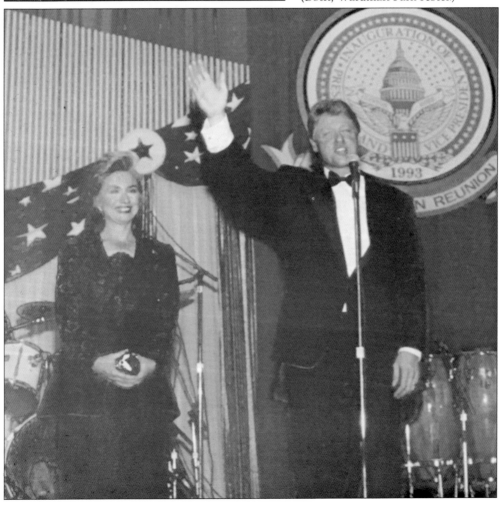

Four

SWIMMING POOLS, GALAS, RECREATION, AND FUN TIMES

Life at Wardman Park has not always been all serious business. Yes, politicians have brokered deals over cocktails in the hotel lounge, and Washington's business community has hosted conventions, association meetings, and important conferences at the hotel. However, the hotel's vast convention and exhibition space has also been utilized for cat shows, alumni gatherings, Girl Scout meetings, and more.

Over the years, the hotel has built a series of ballrooms—each one bigger than the last—and they have been touted as some of the largest in the nation's capital.

And when summer rolls in, along with Washington, DC's stifling heat and humidity, the action at Wardman Park has traditionally shifted to the swimming pool. Since its inception, the pool at Wardman Park has been a popular gathering spot for residents and hotel guests alike. Bathing suit styles may have changed from modest knee-length suits for women to small bikinis and to, at times, somewhat revealing trunks for men, but one constant has remained—the Wardman Park pool has traditionally been regarded as a place to be seen.

Amenities for residents and guests go beyond the pool. Tennis courts, an ice-skating rink, and even a horse saddle club have been available for use over the years. Due to the expansive grounds—16 acres—the hotel ingeniously launched in the 1950s a miniature train that could transport guests all over the property. The Cherry Blossom Special was also used to transport guests' luggage to their rooms.

The Wardman Park Hotel has also seen its share of military action. In the 1940s, the US military utilized the hotel pool to train soldiers how to swim in full fatigues. Additionally, the tall nature of the hotel provided the perfect location for troops to practice rappelling, and at one point in the 1960s, there were Pershing missiles on the grounds.

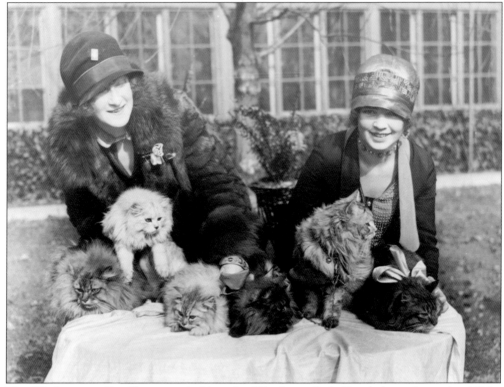

The Washington Cat Show was held at the Wardman Park Hotel throughout the 1920s. Edna B. Doughty (left) and Louise Grogan are pictured here with their extravagant Persian cats. (LOC.)

Mrs. Martin K. Metcalf, wife of Commander Metcalf, USN, holds Pansy, a thoroughbred Turkish cat that used to "meow" in the palace of the sultan of Turkey, her former owner. The cat, brought from Turkey to Washington by Commander Metcalf, was one of the interesting entrants in the cat show held in Washington at the Wardman Park Hotel on February 1 and 2, 1927. (LOC.)

Sweet Briar College alumnae meet for a luncheon at the Wardman Park Hotel in 1939. Shown here are, from left to right, Mrs. Howard Luff, of Cleveland, Ohio, national president of the Sweet Briar Alumnae Association; Mrs. A. Kent Balls; and Mrs. T. Forster, alumnae members. (LOC.)

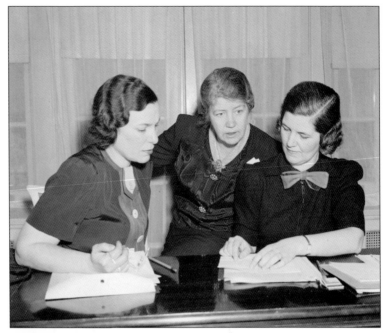

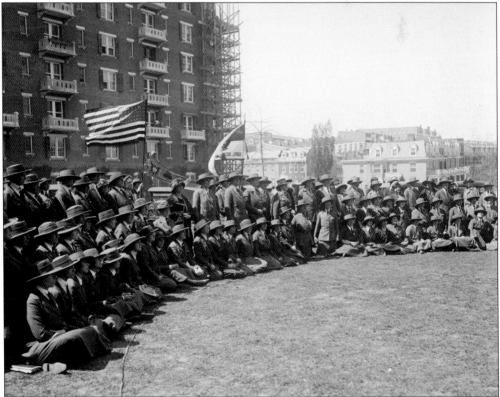

This 1923 photograph shows the gathering of the 9th Annual Convention of Girl Scouts at the hotel. The group met with Lou Henry Hoover, wife of President Hoover, during the convention. (LOC.)

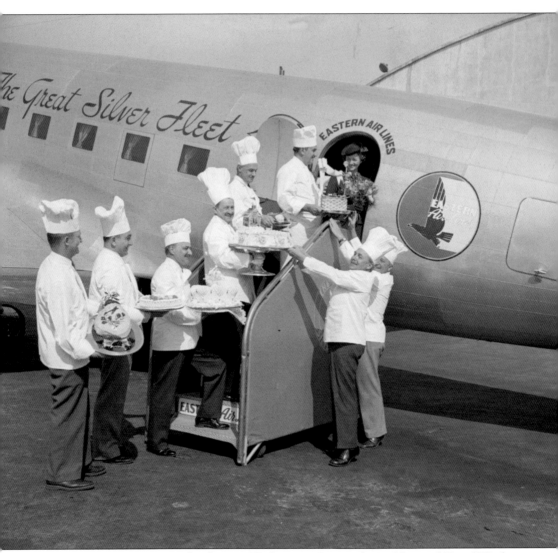

On October 4, 1938, air travelers leaving Washington Airport during National Travel Week were given a special treat. Cakes baked from their favorite recipes were put aboard each plane by chefs of the leading hotels of Washington, DC. Marjorie McKinnon, Eastern Airlines hostess, is pictured receiving the delicacies from, left to right, Theophile Homberger, Hotel Hamilton; Eddie Weber, Shoreham; Joseph Cattaneo, Washington; Fritz Meissner, Hay-Adams; Abraham Grob, Wardman Park; Joseph Tucci, Raleigh; Jacques Haerringer, Shoreham; and Otto Merz, Willard. (LOC.)

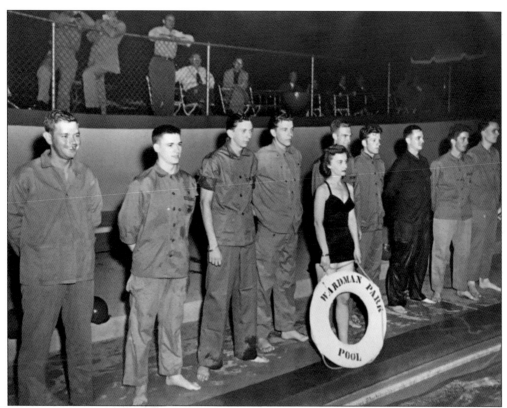

Marine Reserve sergeant Charlotte Foltze stands by with a life preserver at the Wardman Park Hotel pool while more than 50 members of the 5th Marine Reserves learn how to swim with their clothes on. This training exercise took place on June 17, 1949, with US Marine Corps (USMC) brigadier general Merwin H. Silverthorn and other brass watching. (MLK.)

Marine Reserve sergeant Charlotte Foltze is pictured on June 17, 1949, with the 5th Marine Reserves, who are learning how to swim with fatigues on. Present at the maneuvers were Rear Adm. Sidney W. Souers, executive secretary of the National Security Council, and Brig. Gen. Merwin H. Silverthorn, USMC. The training took place in the Wardman Park Hotel pool. (MLK.)

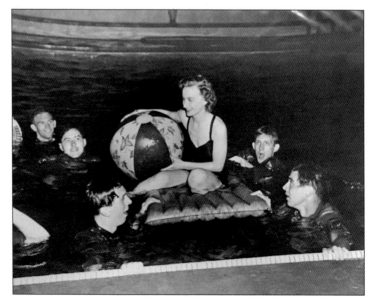

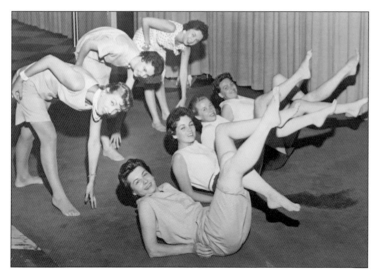

Beginning in May 1958, the female office help at the Sheraton-Park Hotel started to take workouts during their lunch hour. Pictured are, from left to right, (first row) Pat McAndrew, Margie Abell, Inge Koopmann, and Hilda Wolf; (second row) Maybritt Graffius, Pat Meredith, and Barbara Norton. (MLK.)

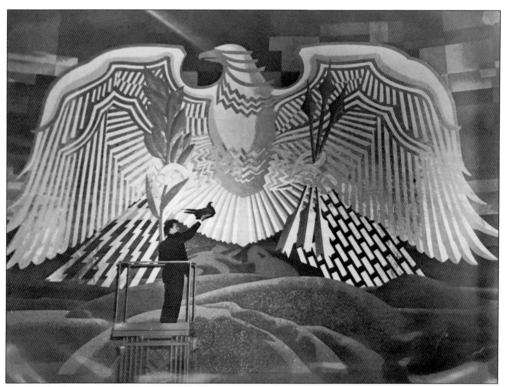

The eagle shown in the Sheraton Hall ballroom is 30 feet high and 35 feet wide. Lumen Martin Winter, the artist, created the fabulous mural after doing research on different types of eagles. The history of the United States, beginning with Paul Revere through to the Atomic Age, is on each side of the eagle and covers the whole south wall of the ballroom. The New York artist spent five months on research and said it was the biggest eagle ever drawn. (MLK.)

These soldiers are rappelling down the side of the Sheraton-Park Hotel in a training exercise on October 3, 1962. Part of an Army Special Forces group, the soldiers include Sgt. Jack Jennings and Sgt. Thomas Butrim. (MLK.)

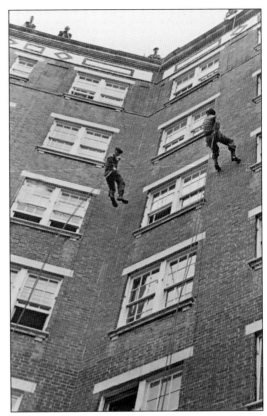

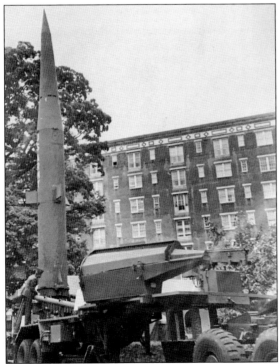

Cold War–era Pershing missiles were displayed in front of the Sheraton-Park Hotel on October 13, 1969. Due to its prime location, the hotel has been involved in many international political events, including espionage. A British spy with the code name "Cynthia" used the hotel as her base to spy on the French Vichy embassy. She would steal important documents and top secret codes and then photograph them in her hotel room. (MLK.)

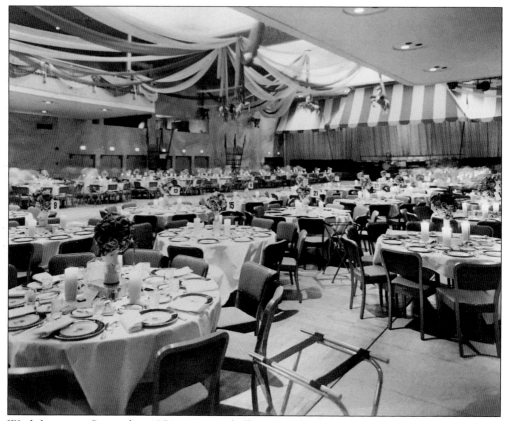

Work began in September 1954 on a new ballroom and exhibition hall at the Sheraton-Park Hotel, and miraculously, within eight months, the project was complete. The new space would accommodate 2,000 people for meals and 3,000 for meetings and was aimed at attracting convention business away from downtown Washington, DC. Workmen worked around the clock to beat the tight deadline for the $1.5 million addition. (MLK.)

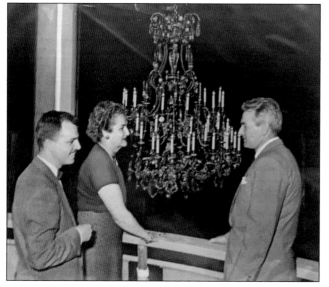

The chandelier in the new ballroom came from a French chateau. Admiring it are, from left to right, David Leport, Mary Morrison Kennedy, and Robert Turcott, project engineer for the builders, from Rhode Island. For the world's largest ballroom, Turcott, at times, had to get daily building permits from district officials, and work had to be paused to get district approvals, as the frantic construction pace was too quick for officials to keep up. (MLK.)

The Sheraton-Park Hotel's chief chef, Edward Stepitch, is pictured in the new ballroom kitchen. The new oven could cook 56 ribs of beef at one time. The ballroom—called the largest ballroom in the world—was completed a week ahead of schedule, and White House officials were consulted during the planning process concerning necessary security for presidential parties. A special roadway and entrance to the ballroom was constructed for security purposes. (MLK.)

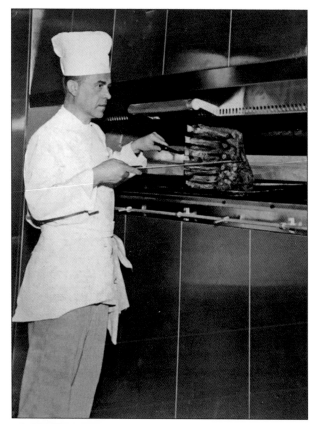

Aiming to increase its convention business, the kitchen in the new ballroom was also enhanced. The air-conditioned ballroom's real standout, according to visitors, was its lighting. The soft, pleasing lighting required about 175,000 watts and was centrally controlled by a switchboard in a room overlooking the dance floor. (MLK.)

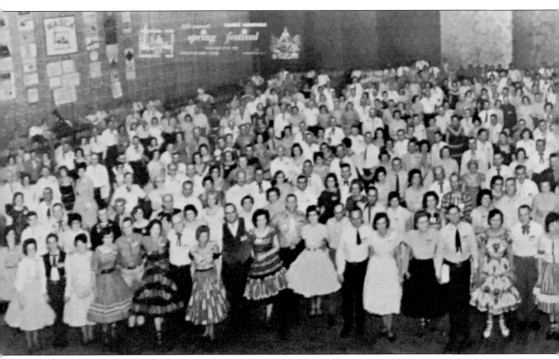

Shown here is the fifth annual Spring Festival held at the Sheraton-Park Hotel on November 27 and 28, 1964. The enormous ballrooms at the hotel were able to accommodate events such as this one with hundreds of square dancers taking part in the festivities. The hotel hosts

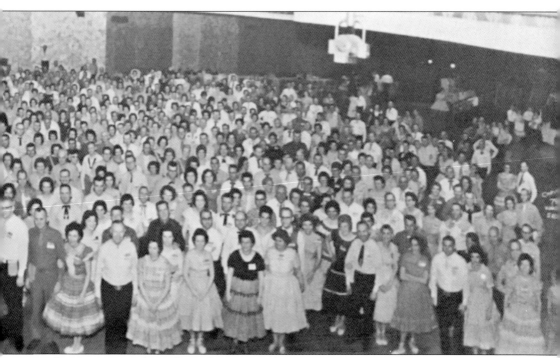

many large meetings throughout the year, and groups return again and again. In fact, the Transportation Research Board held its annual meeting at the Wardman Park Hotel for 65 years. (Authors' collections.)

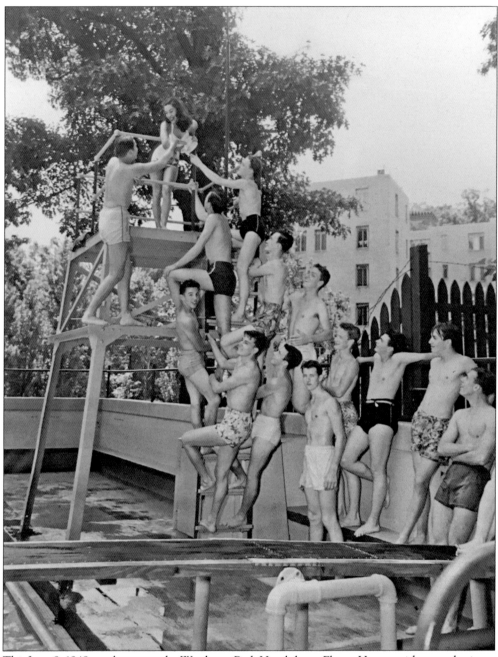

This June 8, 1948, pool scene at the Wardman Park Hotel shows Floren Harper with several suitors. In the early days of television, NBC and other broadcast organizations originated many programs from the hotel, including *The Camel News Caravan*, *The Today Show* (Frank Blair segments), and the *Arthur Murray Dance Program*. (MLK.)

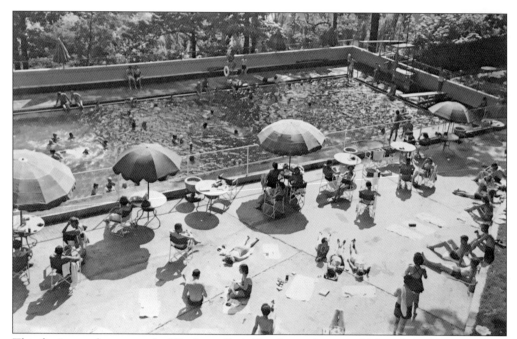

This festive pool scene at the Wardman Park Hotel was photographed on June 30, 1947. Inside the hotel that year, the first televised broadcast of *Meet the Press* took place in the Wardman Tower, where it continued to be televised for decades. (MLK.)

Floren Harper, aspirant thespian, has fun with Capitol Hill page boys in the Wardman Park pool. Washington's notoriously hot and humid summers can be brutal, even for the young set, so the Wardman pool was especially popular. (MLK.)

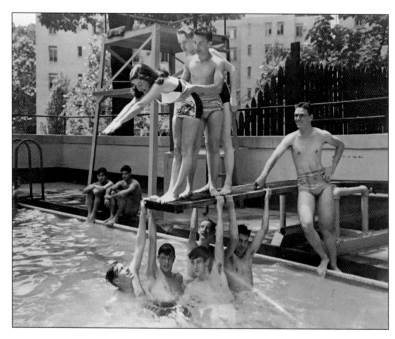

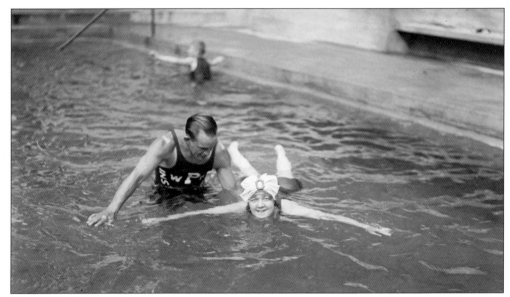

These 1922 photographs show the gay time hotel guests and residents could have at the Wardman Park's swimming pool. However, in 1960, the swimming pool was obliterated to make way for a new ballroom that could accommodate 1,000 persons. The hotel wisely did the construction beginning in January so that the new pool could be constructed by summer. The larger ballroom could accommodate meetings such as the Association of American Law Schools, which has held its annual meeting at Wardman Park Hotel for over 25 years and is booked for future years. (Both, LOC.)

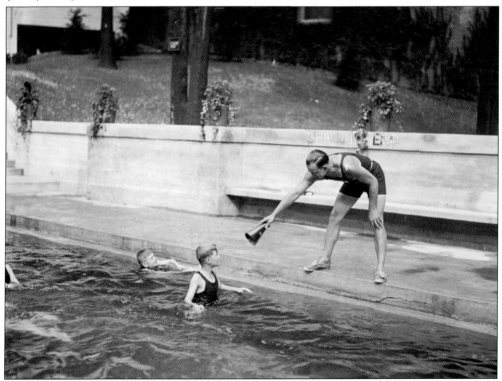

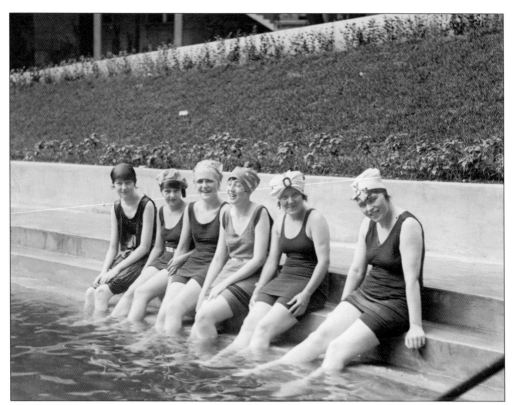

The Wardman Park pool was especially popular with the younger set during the summer. A local newspaper article drew its conclusion as to why: "Not only is the 'sun and swim' habit an enjoyable recreation during Washington's hot summers, but its by-product is a golden tan which brings envious 'oohs' and 'ahs' from friends. Even a lobster red complexion is a pleasant change from winter pallor." (Both, LOC.)

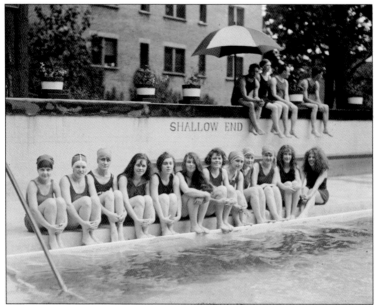

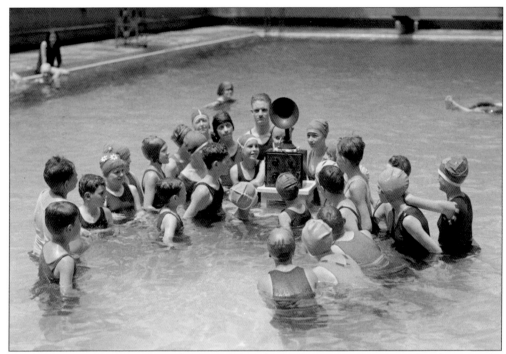

It is unclear why these swimmers have a radio in the swimming pool; it is unsafe to have a radio surrounded by water. Nonetheless, the kids seem to be having quite a fun time. Below, Jerry Managan (left), an employee of the Wardman Park Pool, is pictured with W.G. Farrell (right). (Both, LOC.)

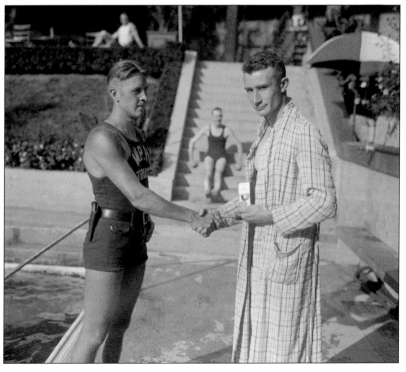

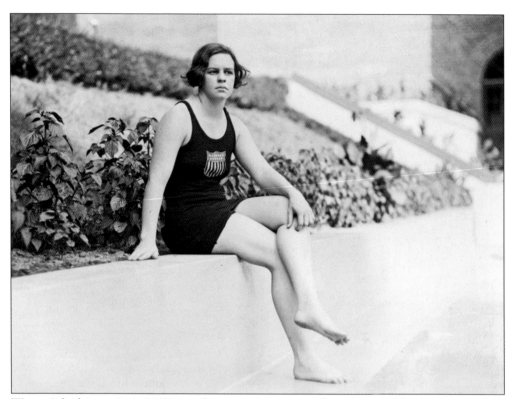

Women's bathing suits in 1927 were far more conservative than the tiny bikinis seen at today's beaches and swimming pools. At Washington, DC's public bathing beaches, there was a male employee to measure the length of the ladies' bathing suits and the amount of exposed legs shown. Oftentimes, hotels and other public spaces also had strict rules on proper swimming attire. (Both, LOC.)

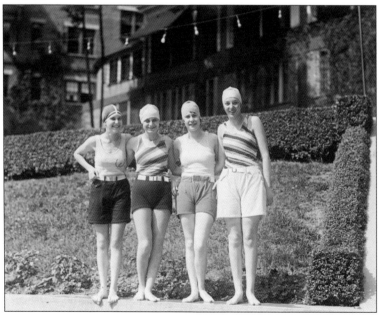

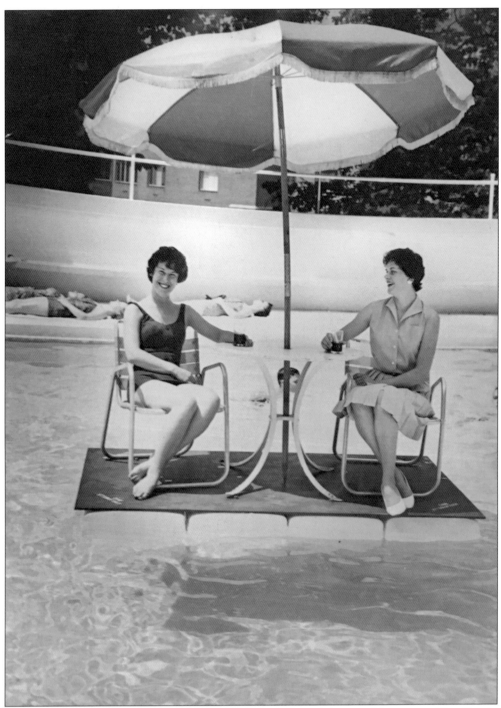

Joan Vermett, a 20-year-old Miss Washington contestant from Arlington, Virginia, and Ray Heath, a 20-year-old resident of southeast Washington, enjoy the pool on their lunch hour in the 1960s. They were photographed floating in the middle of the pool on an innovative "floating veranda" made of a newly developed product called Styrofoam, manufactured by the Dow Chemical Company. (MLK.)

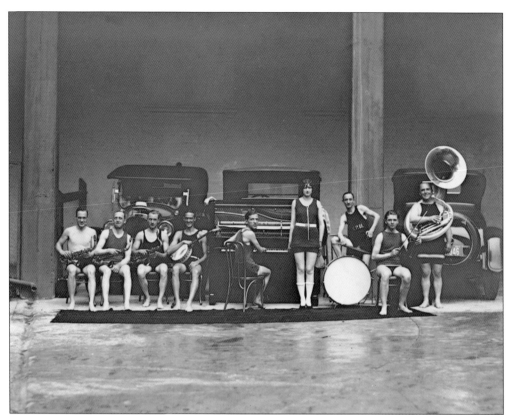

Miss Washington, Helen L. Sweeney, is seen with the Le Paradis orchestra and practicing her diving skills at the Wardman Park pool in 1924. Hotels such as the Wardman Park often brought in musical acts during the summer to entertain hotel guests as they lounged around the pool. (Both, LOC.)

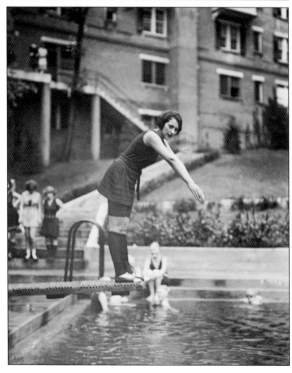

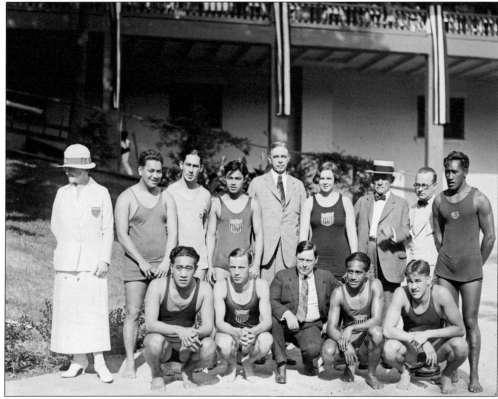

A swimming team from Hawaii (above) is pictured at the Wardman Park pool in 1924. It is unclear why the team was there and how it would have traveled all the way from Hawaii to Washington, DC, in the 1920s. The hotel's pool (below) was a popular destination during the hot summers. Note the lack of chaise lounge chairs along the pool deck, which are so commonplace today. Instead, pool goers hung out on built-in benches or on the adjacent lawn. (Both, LOC.)

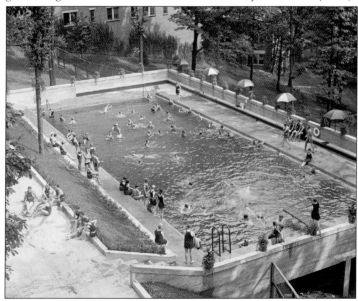

Seen here in 1937 is Mildred Pepper, wife of Claude A. Pepper, a US senator from Florida. She enjoyed a daily dip in the Wardman Park Hotel pool. (LOC.)

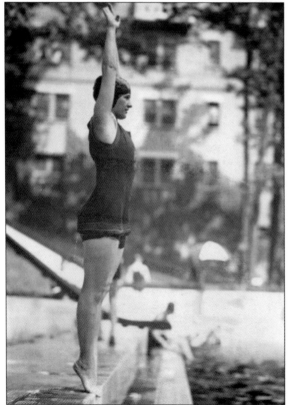

This June 1, 1923, photograph for an article titled "Pretty Girls Frequent Society Bathing Pool" has the following caption: "No wonder the bathing pools are so popular when there are such beautiful mermaids seen diving about as beautiful Miss Katherine Pfeiffer, well known society girl of the Capital, who is a diving pose at the pool in Wardman Park Hotel where several cabinet members and other Capital officials reside." (Authors' collections.)

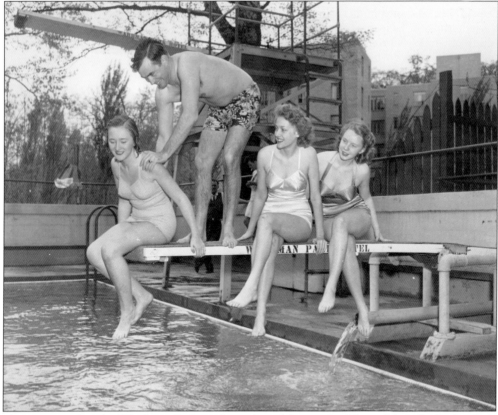

Playing around at the Wardman Park pool are, from left to right, Nancy McCulloch, daughter of Representative and Mrs. William McCulloch, of Ohio; Lt. Cmdr. Leslie Maurer; Mary Louise Lee; and Alden Reed. (Authors' collections.)

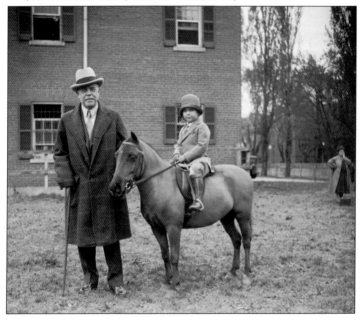

Paulina Longworth, daughter of the Nicholas and Alice Roosevelt Longworth and granddaughter of the late president Theodore Roosevelt, is shown here on April 19, 1930, learning to ride with her father, who became Speaker of the House in 1923. She made her debut as a horsewoman on May 3, 1930, at the Wardman Park Saddle Club with her pony, Snappy. (LOC.)

Pictured is a 1960s menu from the Colonial Room at the hotel. The menu depicts the culinary tastes of Americans at the time, a far cry from fusion style, small plates, ethnic, or other innovative fare seen on today's menus. Diners in Washington, DC, today would also be surprised to see that a diner could order a steak for $4.50 or a broiled brochette of lobster and bacon on toast for $4.25. (Authors' collections.)

Colonial Room Specialty

Served at your table

A generous portion of baked country cured Virginia Ham, raisin currant sauce
(baked in the approved manner)

Candied yams with brandied peaches

Green beans with sugar corn tidbits,
Seasoned with smoked side meat

Mixed garden green salad, gourmet dressing

4.75

Du Jour Selections

Broiled Brochette of Lobster and Bacon on Toast, Tartar Sauce........ 4.25

Baked Veal in Cream with Julienne of Ham and Mushrooms, Korrath... 3.75

Whole Rock Cornish Game Hen Sage Dressing, Sherry Sauce,
Kumquat 3.50

Broiled Delmonico Rib Steak, French Fried Onions, Bordelaise....... 4.50

Choice of Two

Baked Potato on Foil	Nanette Potatoes
Buttered Asparagus	Julienne of Green Beans and Carrots
Boston Lettuce Salad	Emme Salad Gourmet

Breads — one or more served

Beaten Biscuits	Cheese Biscuits	Coach Wheels	Blueberry Muffins
Corn Bread	Popovers	Sally Lawn Muffins	Sweet Potato Biscuits

Beverages

Colonial Room Coffee........ .45 Iced Tea or Coffee........ .45 Tea (pot)...... .45

Sanka....... .45 Buttermilk....... .35 Milk....... .35

From weddings to formal dinners, the new facilities at the Sheraton-Park Hotel added in the 1950s helped elevate Washington as a convention city. (LOC.)

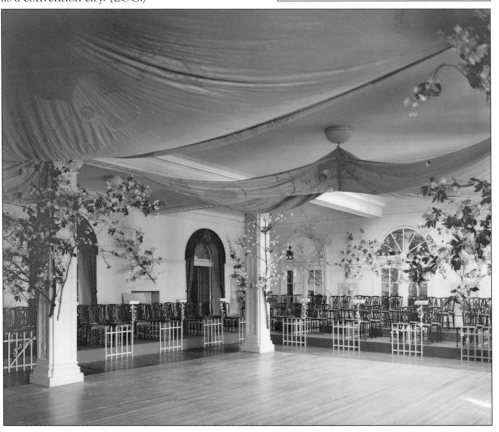

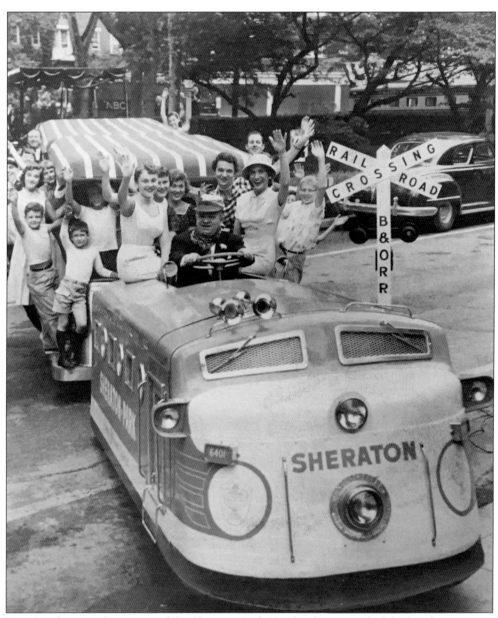

Kurt Smith, general manager of the Sheraton-Park Hotel, takes control of the hotel's miniature 27-passenger train for its first trip around the hotel. A full load of guests had boarded the Sheraton-Park Cherry Blossom Special for a ride around the hotel's 16-acre grounds when this picture was taken for the July 9, 1956, edition of the *Washington Star*. Guests could take the train to the swimming pool, tennis courts, cocktail lounge, and rooms, while the hotel staff utilized the train to transport luggage. It was a quarter-mile walk from the lobby to the east wing and a half-mile journey from the swimming pool to the east wing, so the train was quite a treat for guests. (MLK.)

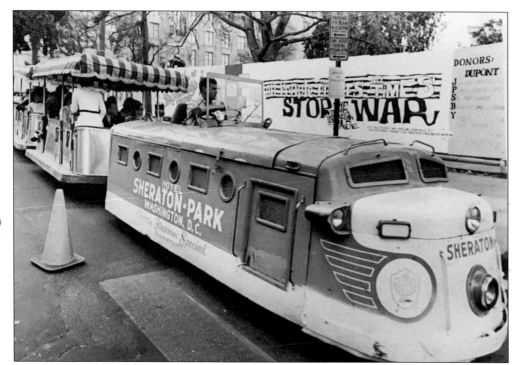

The Sheraton's mini-train, Cherry Blossom Special, is pictured in Lafayette Park in Washington, DC. Antiwar signs flank the train. Even in the luxurious setting of the hotel, guests and residents were not immune to the politically charged atmosphere of Washington, DC. (MLK.)

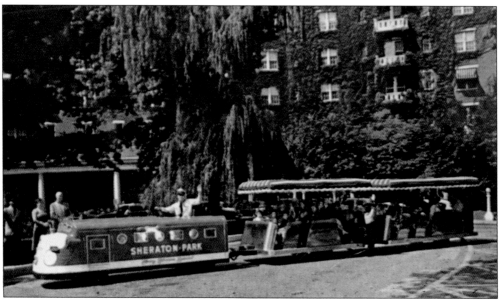

This postcard proudly states that the Sheraton-Park Hotel is "the only hotel in the world offering its own free train service to carry you around its 16 acres of wooded grounds." The postcard also advertises outdoor rooms, all with bath and air-conditioning, free radio and television, outdoor swimming pool, tennis courts, and ample parking facilities. (Authors' collections.)

№ 67387

	Memo	Date	Explanation	Amt Charged	Amt. Credited	Balance Due
1		10·26·44	Room ····	* 6.0.	•	6.00
2		10·27·44	Room ····	* 6.0.	•	12.00
3		10·28·44	Room ····	* 6.0.	•	18.00
4		10·29·44	Restr ----	* 3.0.	•	21.05
5		10·29·44	LD·st ----	* 0.0.	•	22.28
6		NOV·29·44	Phone ·· ··	• 0.10		
7		NOV·29·44	Phone ·· ··	• 0.10		
8		NOV·29·44	Room ·· ··	• 6.00	•	28.48
9		10·30·44	Restr ----	* 4.8.	•	33.28
10		10·30·44	LD·st ----	* 1.1.	•	34.41
11						
12		10·30·44	Room ····	* 6.0.	•	40.41
13		DEC·1·44	Room ····	* 6.00	•	46.41
14						
15						
16						
17						
18						
19						
20						
21						
22						
23						
24						

Bills are payable on presentation.
It is requested that adjustments
be promptly called to the atten-
tion of the Auditing Department.

This 1944 room bill is from Capt. William and Margaret Byrd's honeymoon stay. Captain Byrd was fighting in the Pacific in World War II when he learned that his girlfriend, who was getting her degree in nursing from Johns Hopkins, had been shipped off to a sanitarium because she had been allegedly exposed to tuberculosis while working on the ward. When Captain Byrd found out where she was being held under observation, he broke her out of the sanitarium so they could get married and then honeymoon at Wardman Park. (She never had TB.) Margaret Byrd even ordered her wedding china from a shop that was located in the hotel. (William and Margaret Byrd family.)

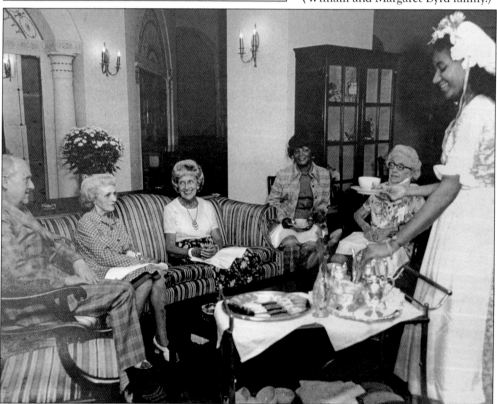

Formal, high tea was served in the lobby of the hotel, a nod to Harry Wardman's fondness for European traditions. Wardman believed in giving hotel guests the best of everything and wanted to provide not just a place to sleep but a meaningful experience. Hence, the lobby regularly held concerts and included bridge and billiard tables to encourage socialization among guests. (Wardman Park Hotel.)

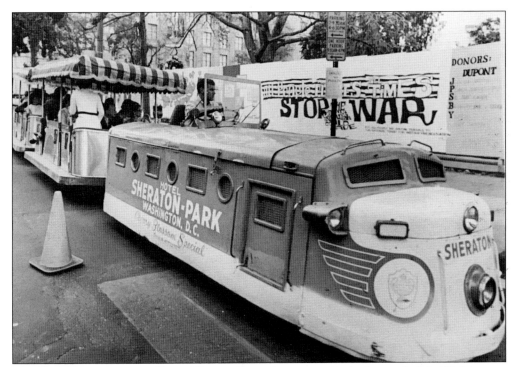

The Sheraton's mini-train, Cherry Blossom Special, is pictured in Lafayette Park in Washington, DC. Antiwar signs flank the train. Even in the luxurious setting of the hotel, guests and residents were not immune to the politically charged atmosphere of Washington, DC. (MLK.)

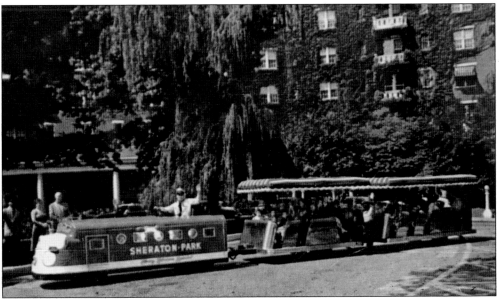

This postcard proudly states that the Sheraton-Park Hotel is "the only hotel in the world offering its own free train service to carry you around its 16 acres of wooded grounds." The postcard also advertises outdoor rooms, all with bath and air-conditioning, free radio and television, outdoor swimming pool, tennis courts, and ample parking facilities. (Authors' collections.)

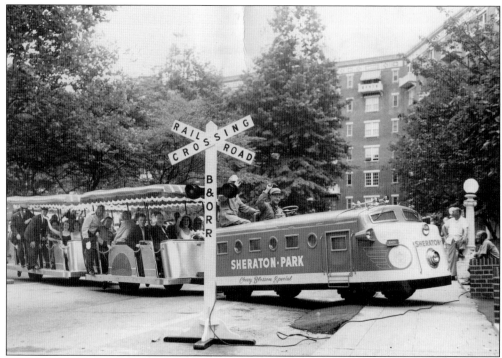

With two passenger cars filled with pleased guests, the Cherry Blossom Special completes its first trip around the hotel's grounds. Designed to make distant parts of the sprawling 1,200-room hotel more accessible to guests and convention members, the engine resembled a miniature diesel, but it was powered by a gasoline engine. The train was free to guests and left every 15 minutes during the day and evening. (Authors' collections.)

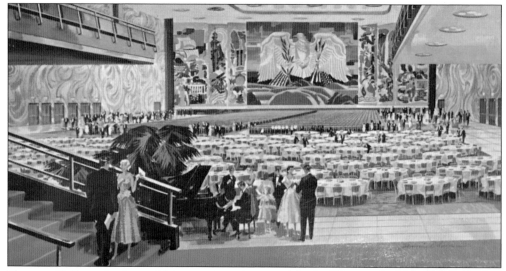

Sheraton Hall was the focus of this promotional postcard for the Sheraton-Park Hotel. "The largest hotel ballroom in the world seating 3,200 persons for banquets and over 4,700 for meetings," the postcard boasts. The large ballrooms have been a big draw for conventions and meetings, including the National Association Realtors Mid-Year Meeting, which has been held at the hotel 41 times and is booked through 2028. (Authors' collections.)

Imogene Taylor, daughter of Adm. E.W. Taylor, USN, who made her debut in the national capital in 1927, was photographed on the Wardman Park tennis courts. (Authors' collections.)

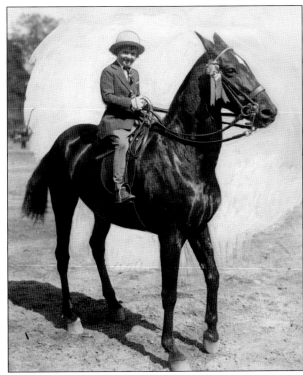

This 1930 photograph shows little Harriet Sommers, who won first prize with her pony in the horse show held at the Wardman Park Saddle Club. (Authors' collections.)

Room F-203 BYRD CAPT & MRS WM H 2/ 5		**WARDMAN PARK HOTEL**			
CAMP LEJEUNE N C 11-26-44 H 7 DAYS		WASHINGTON, D.C.			
				№	67387

Memo		Date	Explanation	Amt. Charged	Amt. Credited	Balance Due
	1	NOV26 44	Room	* 6.0.	*	6.00
	2	NOV27 44	Room	* 6.0.	*	12.00
	3	NOV28 44	Room	* 6.0.	*	18.00
	4	NOV29 44	Restr	* 3.6.	*	21.65
	5	NOV29 44	LDist	* 0.6.	*	22.28
	6	NOV29-44	Phone	*	0.10	
	7	NOV29-44	Phone	*	0.10	
	8	NOV29-44	Room	*	6.00	28.48
	9	NOV30 44	Restr	* 4.8.	*	33.28
	10	NOV30 44	LDist	* 1.1.	*	34.41
	11					
	12	NOV30 44	Room	* 6.0.	*	40.41
	13	DEC-1-44	Room	* 6.00	*	46.41
	14					
	15					
	16					
	17					
	18					
	19					
	20					
	21					
	22					
	23					
	24					

Bills are payable on presentation. It is requested that adjustments be promptly called to the attention of the Auditing Department.

This 1944 room bill is from Capt. William and Margaret Byrd's honeymoon stay. Captain Byrd was fighting in the Pacific in World War II when he learned that his girlfriend, who was getting her degree in nursing from Johns Hopkins, had been shipped off to a sanitarium because she had been allegedly exposed to tuberculosis while working on the ward. When Captain Byrd found out where she was being held under observation, he broke her out of the sanitarium so they could get married and then honeymoon at Wardman Park. (She never had TB.) Margaret Byrd even ordered her wedding china from a shop that was located in the hotel. (William and Margaret Byrd family.)

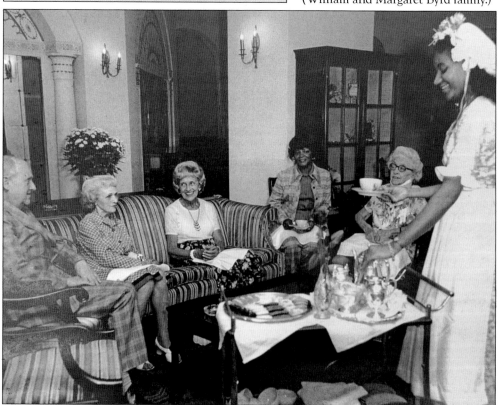

Formal, high tea was served in the lobby of the hotel, a nod to Harry Wardman's fondness for European traditions. Wardman believed in giving hotel guests the best of everything and wanted to provide not just a place to sleep but a meaningful experience. Hence, the lobby regularly held concerts and included bridge and billiard tables to encourage socialization among guests. (Wardman Park Hotel.)

Five

MODERN
TRANSFORMATIONS

It is inevitable that when a hotel stands the test of time for over 100 years, especially one located in a hotly competitive market such as Washington, DC, there will be changes made. Rooms will be updated to accommodate changing lifestyles, expansion efforts will be undertaken to attract more guests, and amenities will be added to allow a hotel to stand out against its competitors.

The need to adapt and change for hotels is never more evident than with the Wardman Park Hotel. Not only has the hotel seen multiple name changes after being acquired by various hotel operators over the years, but the Wardman Park Hotel has also been especially aggressive with expansion, remodeling, and rebranding efforts over its 100 years.

Despite the initial success of the Harry Wardman's hotel after its completion in 1918—as well as the subsequent Wardman Tower apartment building in 1928—Wardman experienced financial difficulties, and he was forced to sell all of his property holdings. In 1953, the Sheraton Corporation purchased the hotel from Washington Properties and renamed it the Sheraton-Park Hotel. Eleven years later, the Motor Inn was added. To attract larger conventions and meetings, Sheraton decided to raze the original hotel in the late 1970s, and a public sale of the Sheraton-Park Hotel furnishings took place. In 1980, the Sheraton Washington Hotel replaced the Sheraton-Park Hotel, connecting the landmark Wardman Tower, the Park Tower, and the Center Tower convention/exhibit area. In 1998, Marriott International took over management and renamed the hotel Washington Marriott Wardman Park Hotel. In 2016, Marriott acquired Starwood Hotels & Resorts Worldwide, which included the Sheraton brand.

While the original Wardman Tower apartment building remains, only the lower two floors are utilized for hotel guests, who enjoy opulent furnishings in grand suites. The Wardman Tower includes 33 luxury suites and connecting rooms including two Presidential Suites and the Langston Hughes Suite. The upper floors have been converted into multimillion-dollar condominiums. In 2014, the Woodley apartments opened adjacent to the hotel with a design than mimics the architectural details seen in the original Wardman Tower.

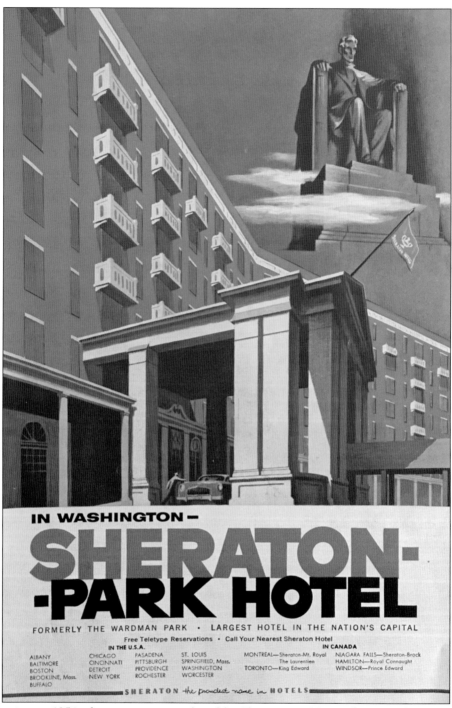

This vintage 1954 advertisement was placed by Sheraton in *National Geographic* magazine as part of the hotel's efforts to market the Sheraton-Park Hotel to a national audience. The advertisement campaign was also critical as it occurred one year after the Sheraton Corporation purchased the formerly named Wardman Park Hotel and rebranded it the Sheraton-Park Hotel. (Authors' collections.)

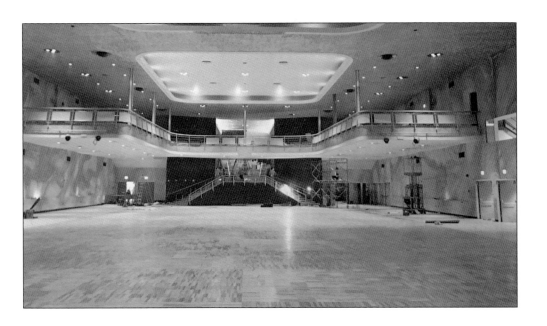

The ballroom that was added in the mid-1950s was the host of a party celebrating the 21st birthday of the Sheraton Corporation. A May 26, 1958, article in the *Washington Star* on the party proclaims that "despite the enormous amount of work [hotel parties] necessitate, the chefs and their helpers love them. It gives them a chance to carry on the European culture of garnishing food, of glazing salmon, of displaying lobster in transparent aspic and serving the pate in a pheasant with full plumage." (Both, MLK.)

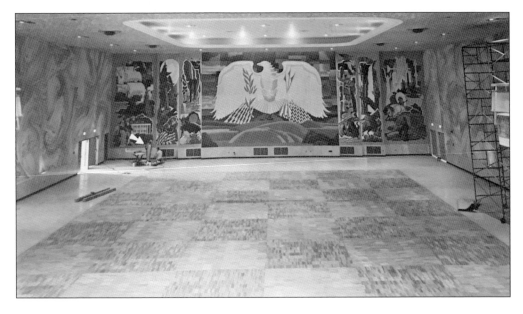

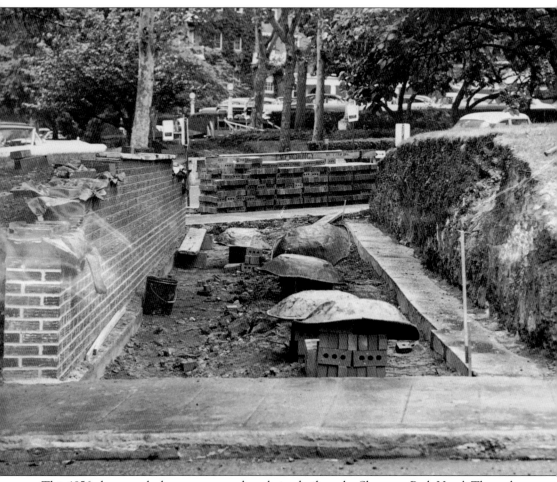

This 1956 photograph shows a new roadway being built at the Sheraton-Park Hotel. Throughout the 1950s, 1960s, 1970s, and beyond, construction activity was at a fever pitch at the hotel. Interior improvements were constant too, including the installation of a new guest dialing system, the first of its type in the area, in 1960. (MLK.)

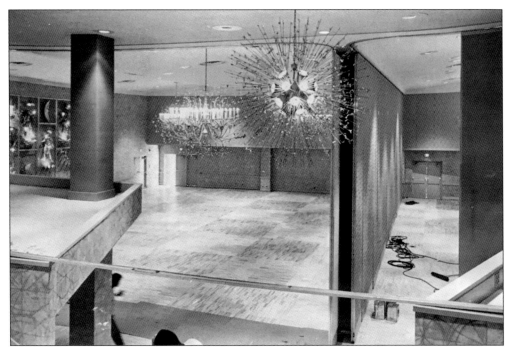

The hotel has added several ballrooms over the years, including an ultramodern one in the 1960s. Cool lighting and soundproof room dividers were seen as innovative at the time. Double walls could also be rolled away to make one huge room. (MLK.)

The hotel has always been well regarded in its ability to adapt to changing architectural movements and its willingness to provide luxurious surroundings for its guests, no matter what the cost. This mid-1950s photograph shows how the hotel had embraced the popular Mid-Century Modern style. (MLK.)

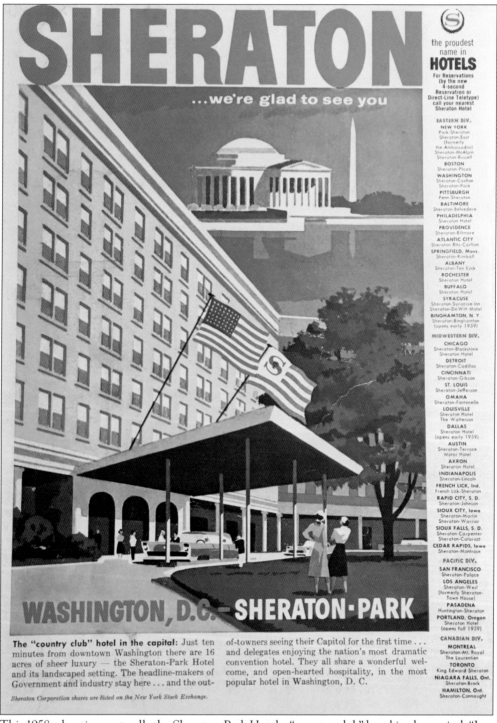

This 1958 advertisement calls the Sheraton-Park Hotel a "country club" hotel in the capital. "Just 10 minutes away from downtown Washington there are 16 acres of sheer luxury . . . the headline-makers of Government and industry stay here . . . and the out-of-towners seeing their Capitol for the first time." (Authors' collections.)

This 1960 photograph shows the top of an antique birdcage. A pair of expensive birdcages sat in the lobby outside of the Gilded Cage cocktail lounge at the Sheraton-Park Hotel. According to reports, "Some gay souvenir hunters took one of the tops. The management of the hotel is sure that the person who took it did not realize the value. It would cost about $1,000 to have it replaced. The cover is hand hammered brass and would have to be made out of the country." The hotel said it would not press charges and the identity of the person would be kept a complete secret if the item was returned. (MLK.)

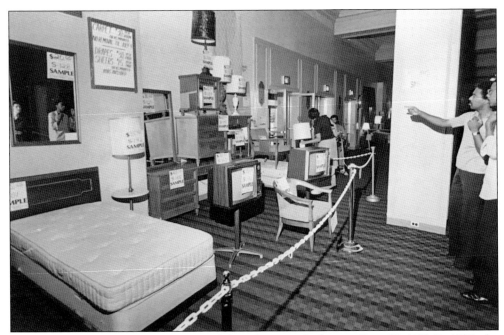

A public sale of the Sheraton-Park Hotel furnishings took place on June 27, 1979. In 1980, the Sheraton Washington Hotel replaced the Sheraton-Park Hotel, connecting the landmark Wardman Tower, the Park Tower, and the Center Tower convention/exhibit area. Marriott International later took over management of the property, renaming the hotel the Washington Marriott Wardman Park Hotel. (MLK.)

The *Washington Star* covered the public sale of furnishings from the Sheraton-Park Hotel in June 1979. Shown here is Richard Hansen, of Bethesda, who purchased a lamp, some blankets, and a pillow. Hansen said, "Prices were about twice as much as a yard sale, but I wanted some things from a prestige hotel." (MLK.)

The 1979 public auction was part of a rebranding effort by the hotel, which also wanted to attract more convention business. In an August 17, 1978, *Washington Post* article, James Gilman, a principal of Hellmuth, Obata, and Kassabaum Development Washington Partnership, says of the need for improvements, "People who go to conventions don't want to stay in an old hotel." (MLK.)

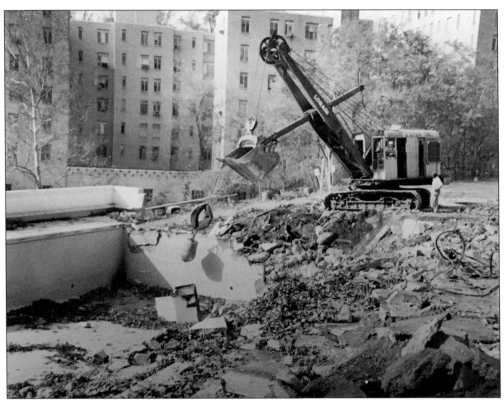

Demolition of the Sheraton-Park Hotel's main building is shown above in 1979; the original structure that was razed is seen below. The new building would allow the hotel to accommodate more guests with an increase of 140 rooms. Exhibition space would also greatly increase from 61,500 to 118,000 square feet, and meeting space would increase from 55,750 to 68,620 square feet, according to a December 17, 1976, article in the *Washington Star*. During construction of the new hotel, the original 1918 building remained open. The hotel has since undergone multiple renovations and transformations. In 1953, the Sheraton Corporation purchased the hotel from Washington Properties. (Above, MLK; below, Wardman Park Hotel.)

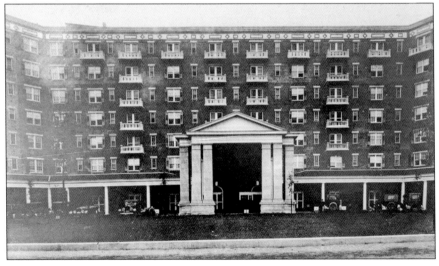

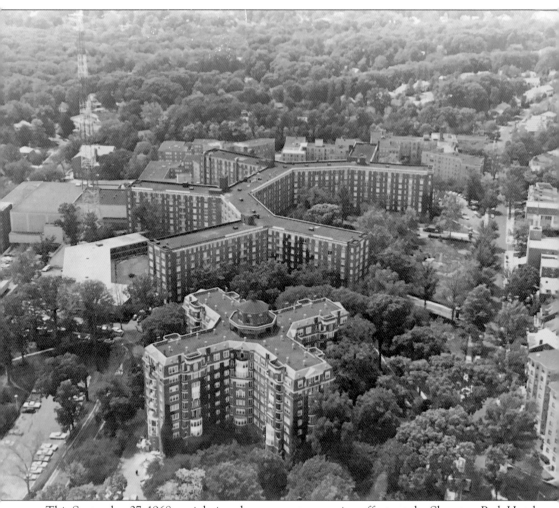

This September 27, 1968, aerial view shows recent expansion efforts at the Sheraton-Park Hotel. In 1964, the Motor Inn opened. The $10 million addition of the Motor Inn included "21 function rooms, banquet halls capable of serving from 50 to 4,700, a 65,000-square-foot exhibit hall, 950 parking spaces, five restaurants, three cocktail lounges and 1,464 guest rooms," according to an August 1964 *Washington Post* article. (MLK.)

Looking to capitalize on the nonstop expansion and construction at the Sheraton-Park Hotel, the savvy owners decided to open the Construction Site Lounge with floor-to-ceiling windows so guests could view the construction site. A May 14, 1978, *Washington Star* article explains that the new lounge was on the corridor that leads left from the main lobby to the Wardman Tower by the old pool, "replacing the old Olympia Lounge, a steamy, bile-green, dismal joint whose sole virtue was in providing dirty old men a chance to ogle at bathers in the pool just outside." The Construction Site Lounge's theme was complete with toy dump trucks that held popcorn and "waitresses wearing yellow hardhats, lumberjack shirts and cutoff blue denim overalls," according to the *Washington Star*. "Authentic construction signs adorn the walls with such messages as 'Safety Plays,' and 'Blasting Zone 1000 Feet.' A half dozen hardhats on the wall next to the Foreman's Shack wing of the bar bear the names of hotel executives." (MLK.)

The quirky Construction Site Lounge is shown here in 1978. Peter Finkhauser, the Sheraton-Park Hotel's food and beverage manager, was quoted in the *Washington Star* as saying, "You can watch [the hotel construction] being built, and then you can see what is going on in the rooms." The hotel also created a signature cocktail called the Sidewalk Super, with a commemorative glass. (MLK.)

This November 3, 1978, photograph in the *Washington Star* depicts the progress being made on the new 10-story, 1,540-room Sheraton-Park Hotel. Plans also called for a complete renovation of the Motor Inn behind the hotel. (MLK.)

Here is a contemporary photograph showcasing the large entrance of the modern wing of the hotel. It features an expansive porte cochere to allow multiple guests to seamlessly check into the hotel at the same time. The new addition was part of the $45 million project that had a timeline of 30 months for completion. (Authors' collections.)

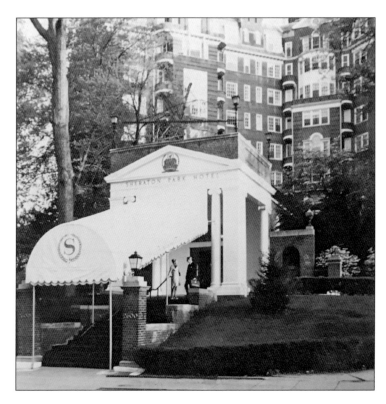

When construction was under way on the new Sheraton-Park Hotel in the late 1970s, the hotel utilized a "fast-track" construction system that allowed it to maintain a minimum of 1,250 rooms throughout the construction process. Additionally, facilities adjacent to the main building, including the 311-room Wardman Tower and the recently renovated ballrooms, were not disturbed. (MLK.)

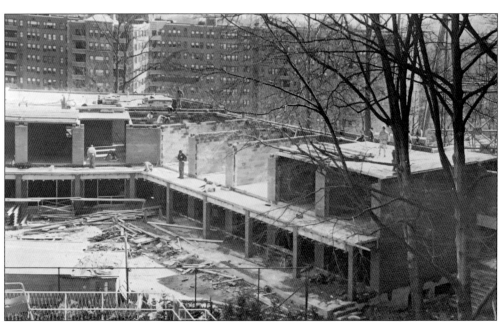

In 1962, the Lanai addition was constructed at the Sheraton-Park Hotel. The $400,000 project consisted of a two-story structure that would adjoin the existing hotel and face the swimming pool. Each Lanai unit had a patio, floor-to-ceiling windows, and modern decor. (MLK.)

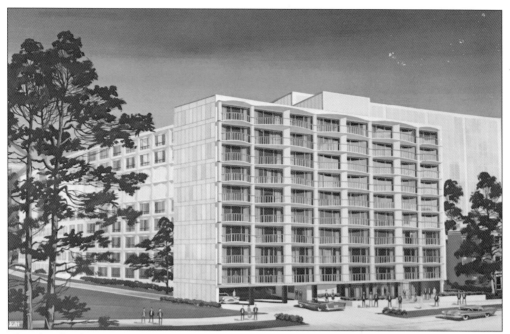

The plan for the new 10-story Motor Inn at the Sheraton-Park Hotel is seen in a 1963 article in the *Washington Star*. It is noted that Clas and Riggs would be the architects. (MLK.)

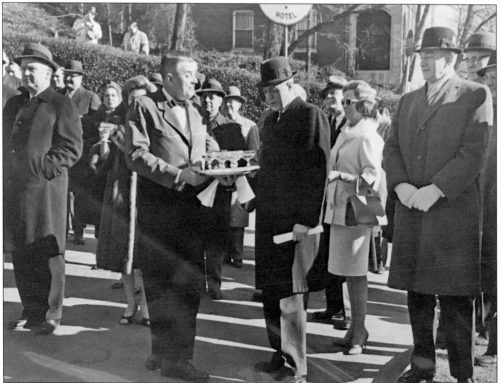

Guests at the 1963 ground-breaking ceremonies for the new Motor Inn enjoy complimentary champagne. The Sheraton hotel chain operated the Sheraton-Park Hotel. (MLK.)

Martha Hodges, wife of the secretary of commerce Luther Hodges, makes a toast to the success of the new Motor Inn. At left is George D. Johnson, vice president of the Sheraton Corporation, and at center Leonard L. Gorrell, general manager of the Sheraton-Park Hotel. The trio is also seen participating in the ground-breaking ceremonies. (Both, MLK.)

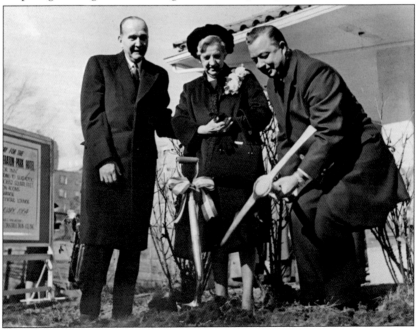

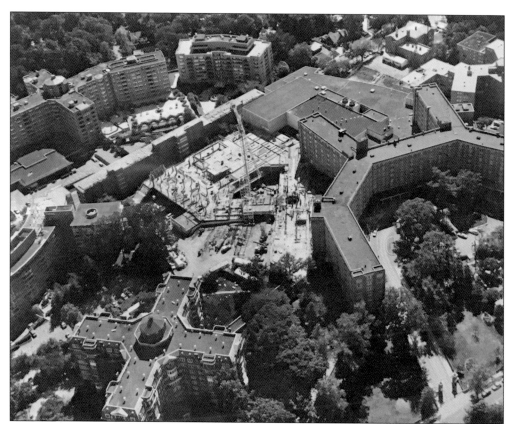

This 1978 photograph ran in the *Washington Star* to point out that the building in the lower left corner (the cross-shaped building, named the K wing of Wardman Towers) would be the new home of Mamie Eisenhower. Neighbors in the adjoining space right next to the former first lady's quarters were members of her Secret Service staff. (MLK.)

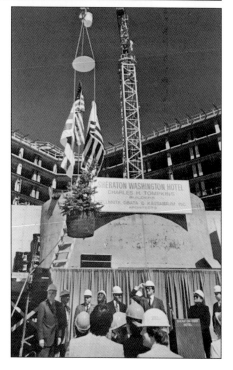

The "topping out ceremony" for the newly named Washington Sheraton Hotel is shown here. A 1984 *Washington Post* article described it as, "A City Within A City." The article noted that the hotel had 1,000 employees, five kitchens (one devoted exclusively to kosher service), six restaurants and lounges, 10 loading docks, 32 miles of carpet, a 3,000-seat ballroom, a 72-foot convention registration desk, and 95,000 square feet of exhibit space. (MLK.)

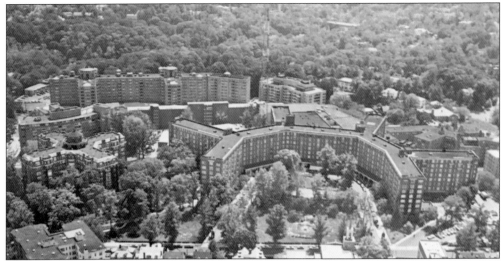

This late-1960s postcard advertises the Sheraton-Park Hotel and Motor Inn as "Washington's Most Fabulous Hotel." In addition to air-conditioned rooms with free radio and television, the hotel also marketed several cocktail lounges, an ice-skating rink, and the largest exhibit area within a hotel. Capitalizing on the hotel's proximity to American University and Georgetown University, the hotel also promoted student and faculty rates. (Authors' collections.)

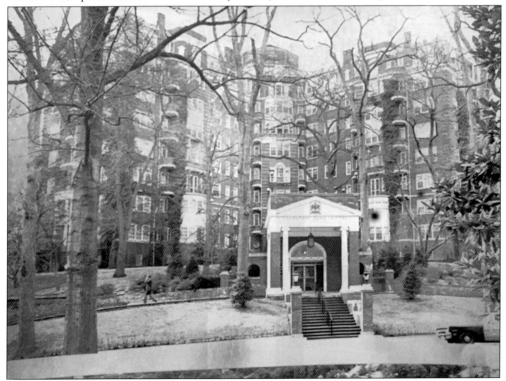

The entrance to the Sheraton-Park Hotel is shown here in 1970. In 1953, the Sheraton Corporation purchased the Wardman Park Hotel and its adjacent luxury apartment house annex. The 32 apartments ranged from 5 to 10 rooms each and were immediately redecorated. Some were subdivided into two-bedroom units. (Authors' collections.)

This 1970s postcard shows the azaleas seen throughout the property of the Sheraton-Park Hotel, as well as the swimming pool. In 1978, to mark the 60th anniversary of the Wardman Park Hotel, Sheraton hosted a gala banquet for more than 200 former permanent residents of the Wardman Park Hotel and Wardman Tower. In 1998, Marriott International took over management and renamed it the Washington Marriott Wardman Park Hotel. In 2016, Marriott acquired Starwood Hotels & Resorts Worldwide, which included the Sheraton brand. (Authors' collections.)

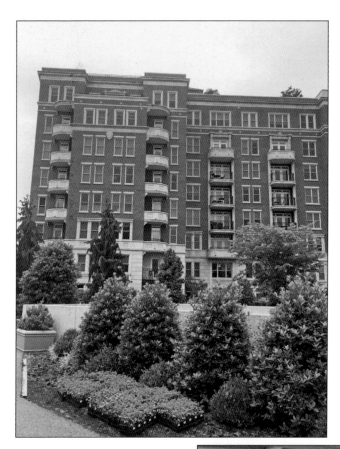

Although they emulate in design the smaller balconies seen at the Wardman Tower, the balconies at the Woodley apartment buildings are larger, allowing guests to enjoy al fresco cocktails or morning coffee. The two buildings are from vastly different time periods but blend old and new in the Woodley Park Historic District. (Authors' collections.)

Guests arriving at Wardman Park Hotel today would feel the same warm reception that greeted patrons a century ago. Today's doorman, bellman, and front desk staff are there to greet guests upon arrival, a hallmark of the emphasis placed on customer service by the hotel throughout the years. (Authors' collections.)

The hotel constantly adapted to the needs of hotel guests and business people by always having a convenient lobby space, which featured dramatic soaring ceilings. Shown here at center is an obelisk mimicking the well-known Washington Monument. (Authors' collections.)

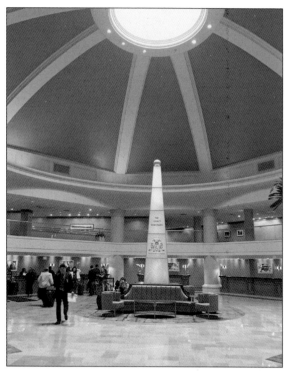

In the Presidential Suite along the historic corridors of the Wardman Tower, guests can find evidence of the century-old furniture that once graced the guest rooms and lobby areas of the hotel. The combination of historic furniture with contemporary lamps is a nod to the seamless combination of old and new. (Authors' collections.)

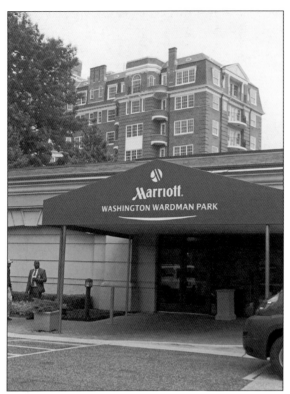

Guests that arrive at today's Wardman Park Hotel may only initially see a modern entrance in concert with the more modern additions; however, further exploration will reveal century-old furnishings and architectural details harkening back to the early 1900s. (Both, authors' collections.)

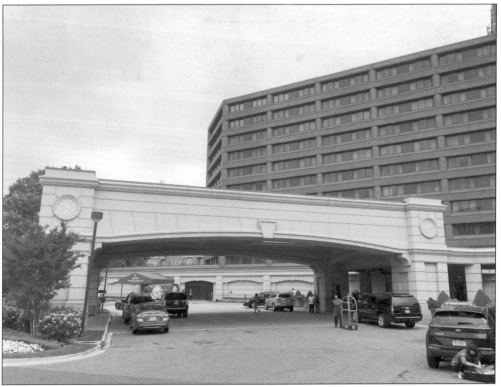

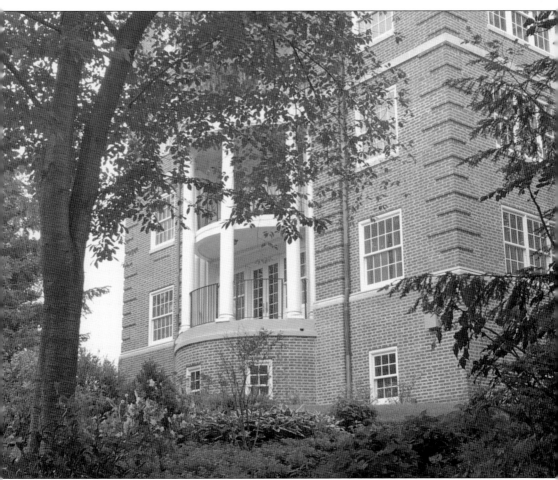

The lower two floors of the Wardman Tower are reserved today for grand suites, including the Presidential Suite and the Langston Hughes Suite, with multiple sitting areas, bathrooms, kitchenettes, multiple balconies, historic and modern furniture, and the ability to host dinner parties for more than a dozen. (Authors' collections.)

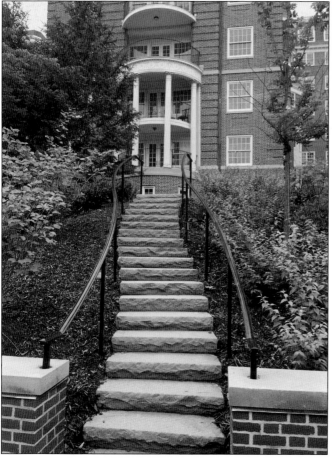

Shown above is the private entrance for residents of the Wardman Tower's luxurious condominiums, which range in price from $3 million to $9 million. At left are the winding steps to the condominiums, which, like similar upscale buildings such as the Waldorf Astoria in New York City, feature a private entrance, allowing residents to be whisked into their homes to escape the busy, sometimes noisy city-life atmosphere. (Authors' collections.)

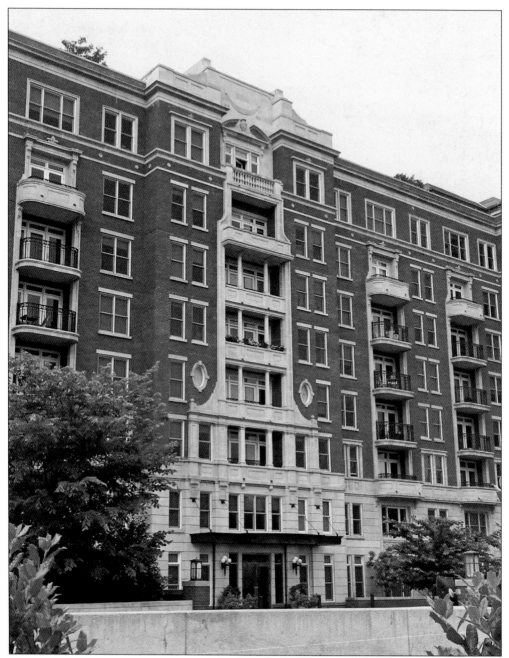

The Woodley apartment building, which opened nearly 100 years after the adjacent Wardman Park Hotel, mimics the architectural details seen in the original Wardman Tower, both in the exterior and the interior public spaces with lavish woodwork and attention to details. Today's apartment residences, which range from studio apartments to luxurious penthouses, feature high ceilings, hardwood walnut flooring, exterior balconies, and marble fireplaces. (Authors' collections.)

Despite several name changes, old structures demolished, new buildings erected, and changes of ownership, several hotel employees have stayed committed to providing hotel guests exceptional service by remaining with the hotel for decades. Shown here are, from left to right, Mai Nguyen, 33 years of service; Mary Walker, 45 years; Robert Adams, 54 years; Isaac Williams, 55 years; and Winsley Saunders, 46 years of service. (Wardman Park Hotel.)

The legacy continues: the Wardman Park Hotel held a series of special events and added this testament to the hotel's 100th birthday, occurring in 2018. (Wardman Park Hotel.)

1918 - 2018

WARDMAN PARK

The Woodley was designed by Cooper Carry, led by principal David Kitchens for the JBG Companies. The 212-unit, Neoclassical, luxury high-rise apartment complex is LEED Silver certified. (Authors' collections.)

Discover Thousands of Local History Books Featuring Millions of Vintage Images

Arcadia Publishing, the leading local history publisher in the United States, is committed to making history accessible and meaningful through publishing books that celebrate and preserve the heritage of America's people and places.

Find more books like this at
www.arcadiapublishing.com

Search for your hometown history, your old stomping grounds, and even your favorite sports team.

Made in the USA
Las Vegas, NV
24 July 2023